IMAGES
of America

HIBBING

MINNESOTA

IMAGES
of America

HIBBING
MINNESOTA

Heather Jo Maki

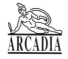

ARCADIA

Published by Arcadia Publishing,
an imprint of Tempus Publishing, Inc.
3047 N. Lincoln Ave., Suite 410
Chicago, IL 60657

Printed in Great Britain.

Library of Congress Catalog Card Number: 2001087676

For all general information contact Arcadia Publishing at:
Telephone 843-853-2070
Fax 843-853-0044
E-Mail sales@arcadiapublishing.com

For customer service and orders:
Toll-Free 1-888-313-2665

Visit us on the internet at http://www.arcadiapublishing.com

CONTENTS

ACKNOWLEDGMENTS

The Hibbing Historical Society would like to thank all of the people who have bestowed their trust in the Society by donating thousands of their most precious memories in the form of these wonderful photographs. We would also like to send out a special thank you to Aubin Studios and Gene Nicollelli of the Greyhound Bus Origin Museum.

On a more personal note, I would like to thank Bert Kreis and Don Messner who helped me greatly, though unwittingly, in the writing of this book. I would also like to thank the staff at the Hibbing Public Library and the Chicago Public Library for being so patient with me and going out of their way to help with the research of this book. I would also like to thank my grandfather, Conrad Peterzen Sr., genealogist at Ironworld, for keeping me amused when I was becoming very tired of looking through each and every one of the thousands of photographs. That brings me to the Ironworld Discovery Center and Ed Nelson. Thank you for taking such good care of so many of those photos! Lest I forget, to Claire Reynolds who actually made me laugh more than she made me think, but what are friends for! And last, but not least, my heartfelt gratitude goes out to Charles Cedar Jr. for offering his services and then taking the time to write the terrific introduction.

This project has been very rewarding, and I (and everyone I've bored with stories) have learned so much. I hope you enjoy reading it half as much as I've enjoyed writing it.

Heather Jo Maki
Manager, Hibbing Historical Society & Museum

INTRODUCTION

Surrounded by large stands of virgin white and red pines, an enterprising iron prospector named Frank Hibbing set up camp on a bitterly cold winter day in January of 1892. When he awoke the next day, he insisted that there was iron beneath him, he could "feel it in his bones." Whether it was truly iron he sensed or simply the bitter cold, we will never know, but he would eventually stake his claim near that campsite. Hibbing had worked in the region of the recently discovered Vermilion and Mesabi Iron Ranges for several years. His intuition proved correct, and after digging several test pits, a rich body of iron ore was found.

Beginning as a small collection of tents and log cabins, the village of Hibbing, Minnesota, was incorporated in August of 1893. The new village grew rapidly once the rich ore from the surrounding mines began to ship to the steel mills in the East. Hibbing became the largest of the many mining towns that were springing up along the Mesabi Range.

Immigrants of many ethnic backgrounds such as Finnish, Italian, Slavic, Swedish, and Greek poured into the region to work in the iron ore mines. People of such diverse ethnic backgrounds gave Hibbing a unique culture that is still evident today.

Through taxation of the mining companies and the political leadership of Mayor Victor Power, in 1913 Hibbing began an era of unprecedented public works projects that drew national attention. Eventually, the village would come to have conveniences that would otherwise be found only in the most modern cities of the day. Beautiful schools, churches, a large public library, a spacious park complete with greenhouses, a band shell, and a zoo were just some of the unique facilities that drew people to this growing village.

Many other small mining towns or "locations," as they are known, sprang up at the edges of the ever growing number of open pit mines. Locations such as Pool, Mahoning, Penobscot, Carson Lake, Kitzville, Webb, Agnew, Leetonia, Kerr, and many others were all once vibrant communities. However, many of them are now gone. They have been abandoned, absorbed into larger communities, or swallowed up by the very open pit mines that brought about their creation. Hibbing too was almost lost to the encroaching mine that gave it life. Little did Frank Hibbing know that directly below his village lay one of the richest deposits of iron ore in the world, which is still producing ore to this day.

Hibbing had to move! The entire town—buildings and all—needed to go. A deal was struck with the mining companies, and beginning in the early 1920s many of the buildings and homes that could be moved were loaded up and hauled a few miles south to a new town site. Moving an entire town was a difficult and expensive undertaking, but the rich ore below was too valuable to pass up. In addition to paying for much of the cost of moving the existing buildings, the mining company financed the new construction of many lavish city buildings including the still magnificent Hibbing High School.

The now immense Hull-Rust-Mahoning Mine eventually consumed much of the original village site, which is now referred to as North Hibbing. Vacant streets leading to nowhere, empty foundations, crumbling sidewalks, and a few street signs are all that remain. While the buildings and people are gone from North Hibbing, their spirit lives on, reborn in a new location.

Hibbing survived, and its citizens have transformed the present-day city into a regional center for health care, education, and manufacturing. However, as it was in the beginning, iron mining remains the lifeblood of this still thriving city.

The intent of this book is to provide glimpses into the rich and colorful history of Hibbing and its people. We hope you enjoy it!

Charles Cedar, Jr.
Hibbing Historical Society, Board of Governors

One

LOGGING, MINING, AND FRANK

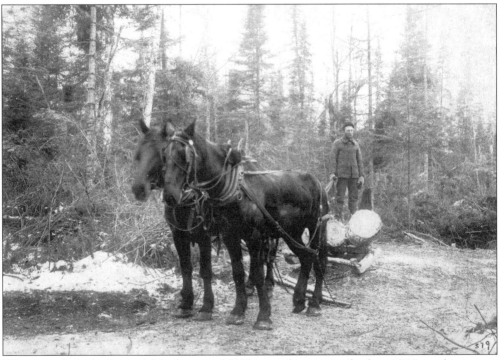

What stands as the beautiful little city of Hibbing today was in the late 1800s nothing more than almost virgin White Pine forests. Loggers were soon coming to the area in droves. This two-horse team is part of the Powers and Simpson Logging operation in 1905. Teams of larger numbers were also commonly used.

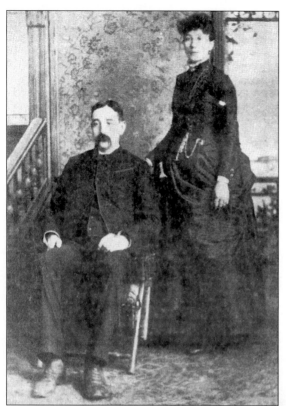

Upon coming to America, Frank Hibbing set out to learn about timber cruising and prospecting. Using this knowledge, he set his sights on the area that was to eventually become his namesake. In late 1891 Mr. Hibbing received some financial backing from his friend A.J. Trimble, and on January 12, 1892, he stepped out of his tent and told Mr. Trimble, "I believe there is iron under me, my bones feel rusty and chilly." That very day, they found that there was. Pictured here are Frank and his wife Barbara on their wedding day on May 14, 1885.

Though most mines almost immediately became open pit mines, many of them started as underground mines. This scene is typical of the early underground mines with the men wearing candles on their hats.

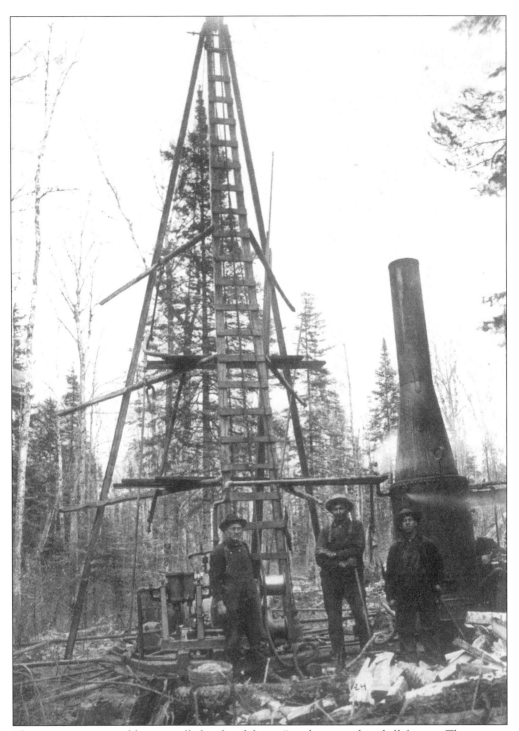

The structure pictured here is called a "head frame," and was used to drill for ore. The men in this picture, from left to right, are: C.O. Johnson, Johnson's brother who is believed to have gone back to the "old country," and Emil Gustavson. This photograph was taken in 1900 in the Mahoning area.

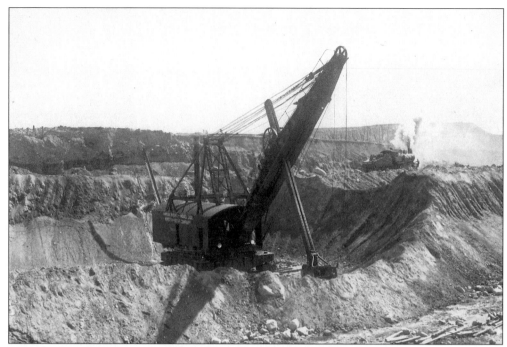

After the loggers removed the White Pine, the open pit mining started. Even in the beginning it was a fairly efficient operation, though not particularly pretty. The shovel here is working at the Webb mine in 1917.

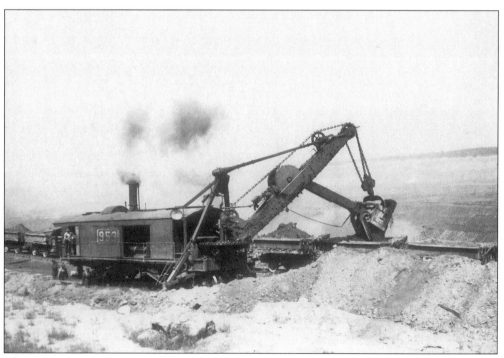

These shovels ran on steam and would scrape out chunks of ore, depositing them in the waiting train cars that would carry the ore out of the mines. This photo was taken in July of 1919.

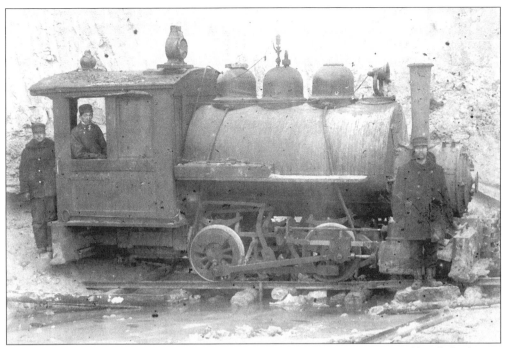

These cute little engines were called "dinkies." Small but powerful, they would pull the heavy, ore-laden trains out of the mine pits, and effectively ended the days of horses and mules in the open pits. The man on the engine is Ira Smith.

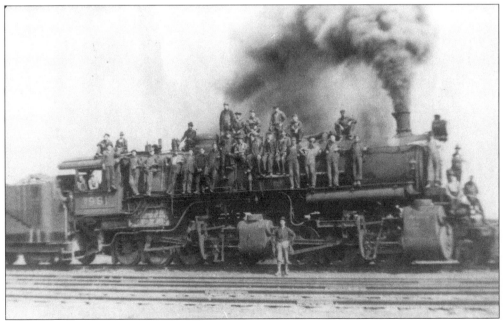

Taken at the Kelly Lake Yards, this photo is of a larger steam engine. These engines ultimately replaced the dinkies, as they could carry many times the tonnage. They were also used to start the ore on its long journey to the steel mills. They pulled the long trains to docks in Duluth on Lake Superior.

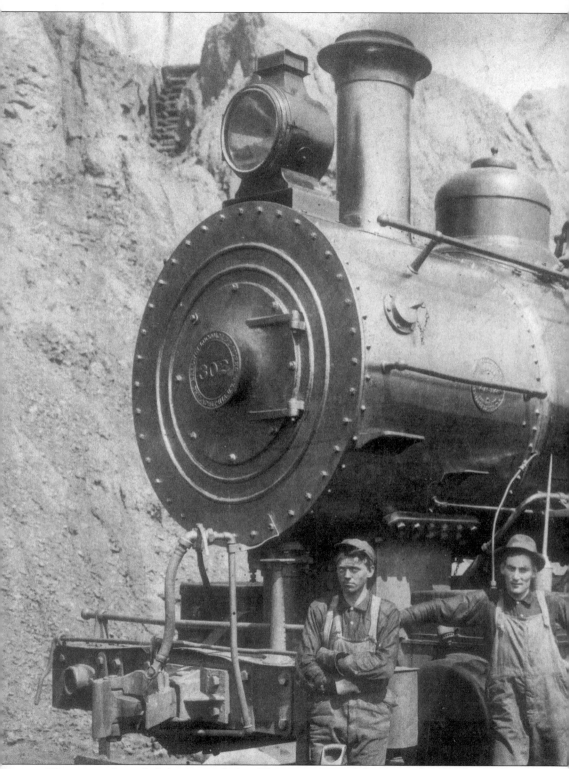

This is another, slightly newer dinky. The men pictured here are, from left to right: Bill

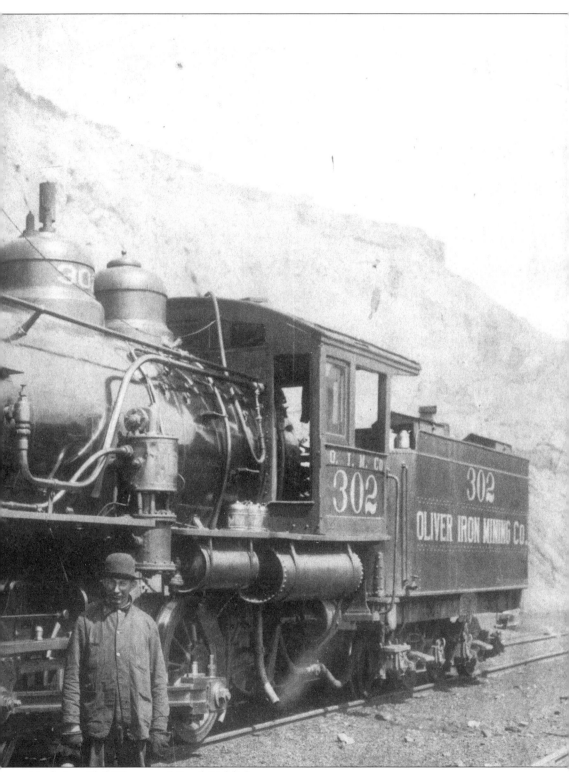

Duchaine, Phil Silvers, and Frank Ryhlick.

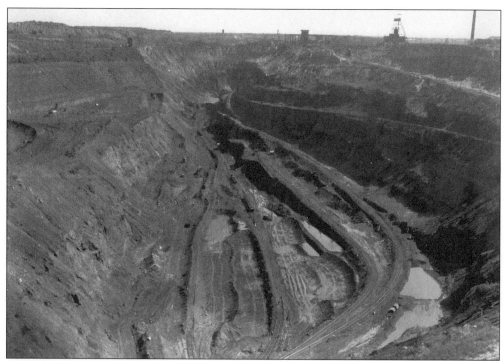

This photo of the Susquehanna pit in September of 1940 shows how the topography of the area would be constantly and drastically changed. The pits would get deeper and the train tracks would have to be moved continually.

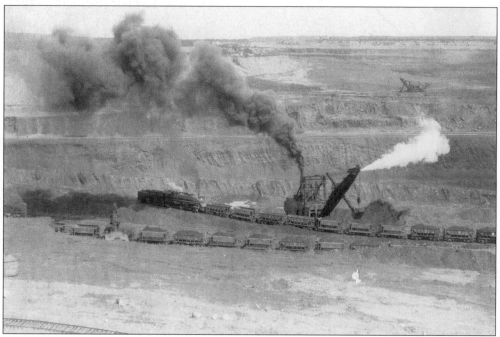

Pictured here are a couple of 300-ton-class steam shovels loading ore at the Sellers mine. This photograph was taken c. 1910.

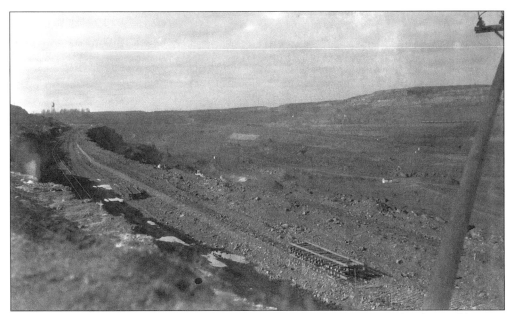

In some instances, the pits would become so large they would run into each other and become one big pit. This is the view from across the Rust pit to the Mahoning pit, taken on November 12, 1938. Eventually, these pits would become the Hull-Rust-Mahoning—one the world's largest open-pit mines and the largest open-pit ore mine.

In some cases, miners did more than mine. These men would cut timbers to use for bearing up walls in the Albany underground mine. Taken in 1906, the men pictured here, from left to right, are Louis Stolsis and Algot Lidholm.

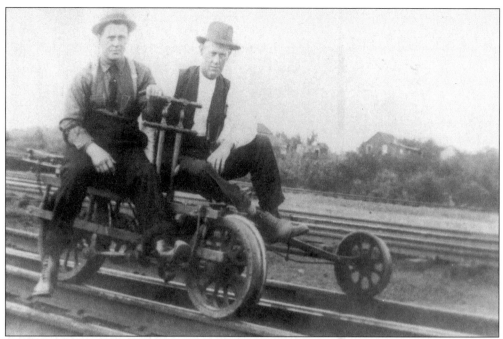

Train tracks had to be checked by hand frequently to help avoid costly accidents. Using a cart designed for the purpose, these men are checking track at Stevenson Location.

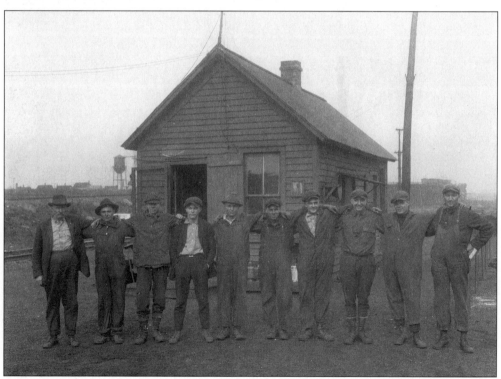

Miners have always been a hardy bunch and ethnically diverse, but as is evident in this picture, the camaraderie is strong. This is the sampling staff of Hull-Rust in October of 1920.

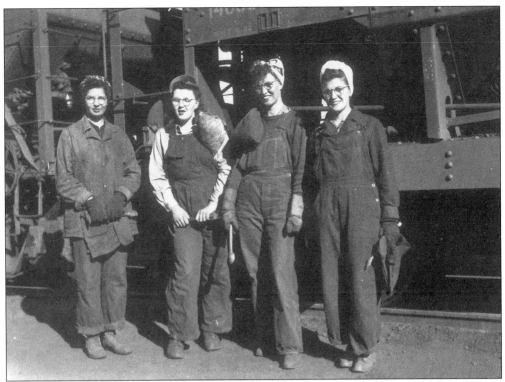

Mining is not an occupation solely for men, especially during the war years. These samplers are posing in front of an ore train on October 13, 1944.

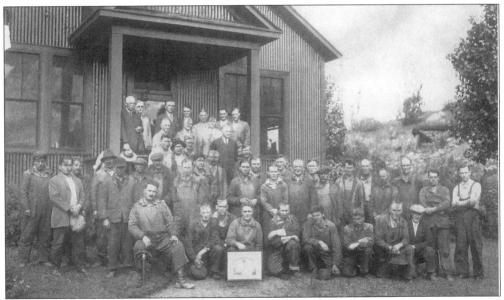

Although safety in the beginning was not of great importance to the mining companies, it all changed with the advent of labor unions. Pictured here are winners of the Joseph A. Holmes Safety Association Certificate of Honor. These certificates were given according to man-hours accumulated with low accident frequency rates.

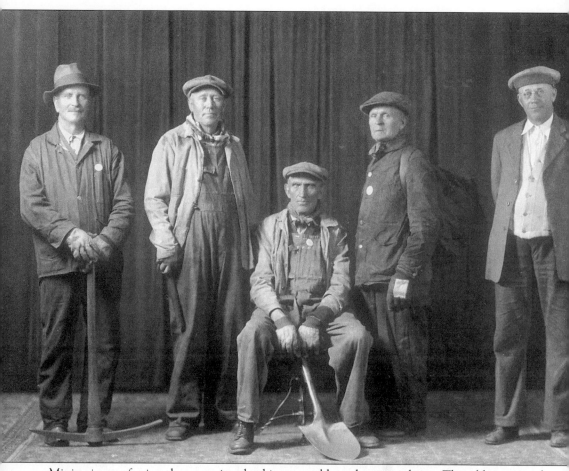

Mining is a profession that once involved in, one seldom chooses to leave. This older group of gentlemen pose for the camera, obviously proud of what they do for a living. From left to right, they are: Ole Erickson, A. Ecklund, Olof Rodin, Carl Johnson, and an unidentified man.

Two

LIVING AND WORKING IN THE "MELTING POT"

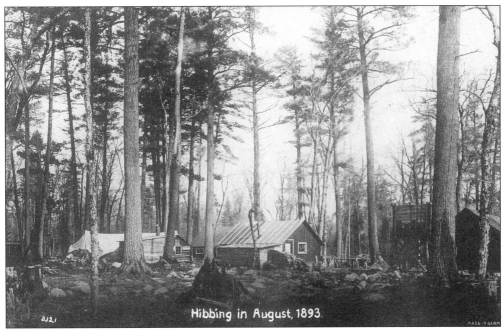

Hibbing in August, 1893.

Hibbing was incorporated on August 15, 1893, by a vote of 105 to 1. What started out as a small settlement of tents and tarpaper shacks was soon to grow and become a bustling little metropolis. Looking at this picture of Hibbing in 1893, it is hard to imagine the little community's grand future.

The little town grew, and these are a few of the people who made that happen. From left to right, they are: J.F. (Fred) Twitchell, the first village president as well as first real estate agent; Dennis Haley, who served as an inspector for the first election and as the first treasurer; and Peter McHardy, the first lumber dealer and tenth village president, serving in 1905.

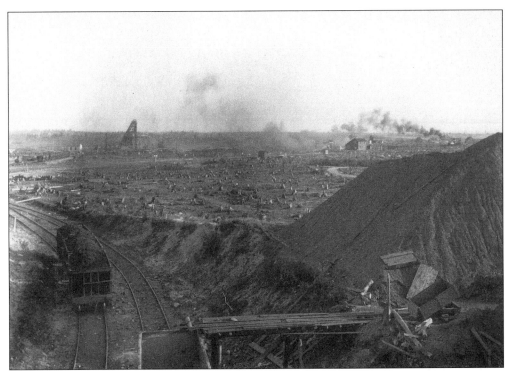

The landscape changed drastically. It no longer held the beautiful pine forests, but instead was filled with mine pits, mining equipment, and stumps left over from logging operations. Still, the times were a changin'…

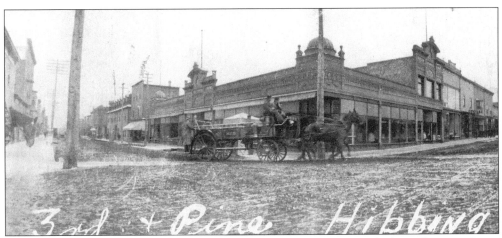

Just 10 short years after the town was started it had become a quaint, little settlement of over 3,500 people. This view of the corner of Third Avenue and Pine Street, taken in 1903, shows the wooden sidewalks built to keep pedestrians out of the messy streets. It was not long after that the streets in the village were paved with small, wooden blocks.

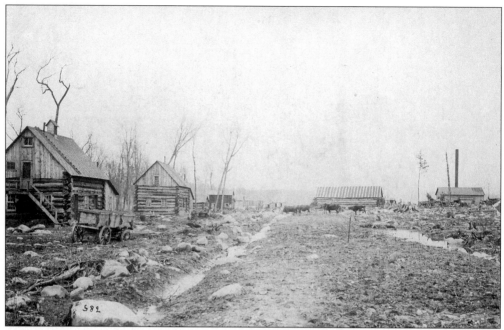

As the town was expanding, so too were the mines. Mining companies started building little communities closer to the mines. They would lease the houses to the miners at very reasonable prices. These communities were known as "locations" and some still exist to this day. This is Stevenson Location in 1901.

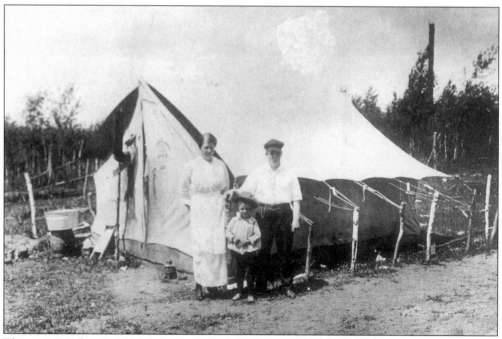

This picture taken in 1916 shows some early Kelly Lake residents, the Oquist family. From left to right, they are: Anna, Edward, and Charlie. Charlie was sent to Kelly Lake to work on the railroad, and in the beginning, his family had to live in this tent.

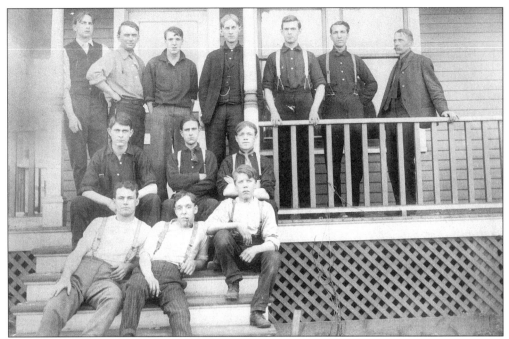

These young men posed for this photo in July of 1907. Pictured, from left to right are: (front row) unidentified, G. Casey, and (?) Rathraup; (middle row) (?) Davey, (?) Bates, and (?) Kropidlowski; (back row) (?) Griese, (?) Tatro, (?) Barnard, (?) Webster, W. Camp, (?) Schneider, and (?) Wylie.

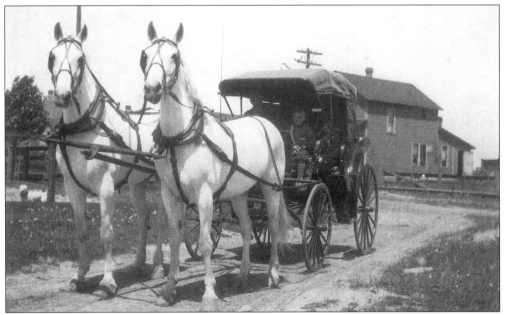

The early days of Hibbing were wild and woolly, but families could always find less rowdy ways to spend their free time. This beautifully matched team of horses is taking the Silliman family out for a Sunday drive on a sunny afternoon in 1908. Trips such as these were events written about in the Society column.

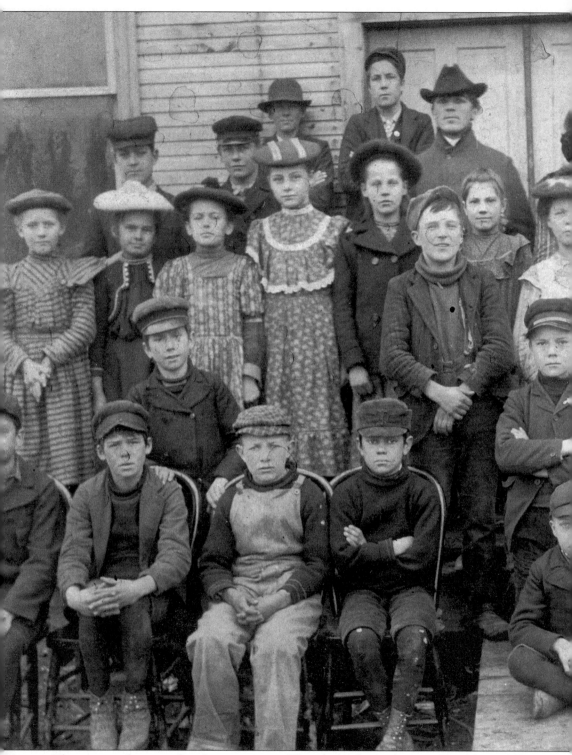

The town and surrounding locations were filling up with immigrants. Forty-three different nationalities were represented, making Hibbing a true "melting pot." This photo was taken in

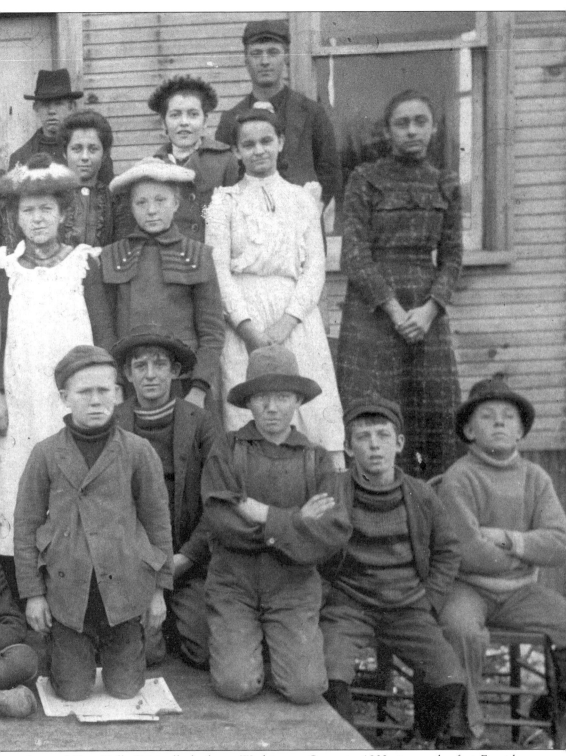

front of Finn Hall. Originally built on Washington Street in 1902, it was the first Finnish workers' hall in America. In 1906, a new hall was built on Lincoln Street.

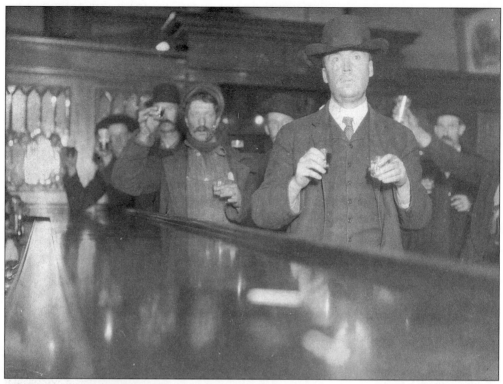

Pictured above are some "two-fisted" drinkers at Thomas F. Roddy's Old Bar in 1898. In 1893, there were already eight saloons. At one time, there were over 60 saloons in the little town, many of which had "houses of ill fame" above them. Gambling is also reputed to have been a popular pastime. The first roulette wheel was brought into town by Dr. French, but was taken to Duluth on January 1, 1900.

John Meehan served as the first policeman and then the first chief of police in Hibbing. He is pictured here in 1896. The first arrest, made in town, was of a man called "Paddy the Pig" who stole a ham from the Gandsey grocery store.

The "wild west" quality of the town contributed to a fair amount of violent crime until the 1920s, when the police force reached a peak in manpower, employing 75 to 100 men. Men on the force had to be tough. The *Hibbing Daily Tribune* relates the story of 160-pound Officer Eric Nord who, "according to legend, subdued a 200-pound miner and then carried him on his back to the police station." Pictured here is the 1904-1905 police department. From left to right, they are: (back row) Eric Nord, Frank Haben, and John Pakie; (front row) William Meisner, Pete Wring, and Henry Enright.

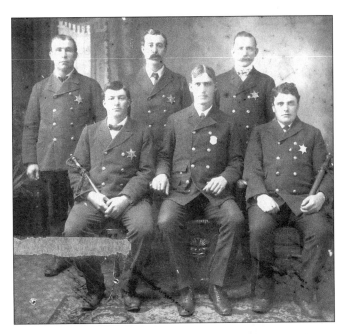

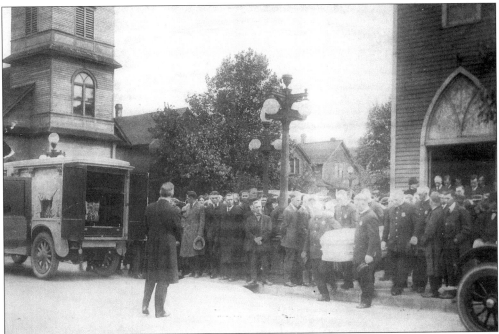

On September 12, 1921, funerals were held for three officers gunned down in the line of duty. One was for patrolman William Kohrt at the Grace Lutheran Church and this one for Chief Daniel Hayes and Chief of Detectives Eugene Cassidy at the Blessed Sacrament Church. These men were killed on September 8th, in Nelson Location, trying to arrest John (Black Jack) Webb for the attempted rape of his own 13-year-old daughter. A huge manhunt was started and a cabin in Kitzville that Webb was holed up in was surrounded. Webb, realizing that he had no chance of escape, shot and killed himself on September 14th. The officers strapped his body to the running board of the patrol car and drove back into town, "whooping and hollering."

On October 28, 1910, Minnesota's only known duel with an immediate fatality occurred in Hibbing. The duel took place between Sam Kacich and Pete Radovich. Sam (the survivor) related his story to Secretary of Police, C.E. Everett:

"The following is about as stated by Sam Kacich to me as he said they were partners working at the Harold mine on contract work, but a disagreement came up. They decided to go to their shack, change clothes, go into town and fight it out, which they did. The first place they stopped was at Jake Cohen's on Pine Street where Sam bought a tablet and wrote out an agreement, which they both signed, stating that the one that lived was to have the property in the country that belonged to the other, then bought a pound of grapes and ate them, then bought two revolvers. They had black grips on them, which they had changed to pearl ones, then they bought a box of shells and each took a revolver. They started down Pine Street but would go into most every saloon and take another drink until they reached Third Avenue, then they started down that and stopped at the saloons for another drink until they reached the Great Northern tracks. They turned and started out on the tracks for the location, but when they reached First Avenue, they decided it would be better to finish it off there, where it would be handy for the police, which they did about as follows: stepping apart and placing their left feet together, then doing the same with their left hands, each holding a revolver in their right hand and they were to fire when the word was given, which they did with the following results: The bullet entered just below and to the left of Pete's face and came out of the back of his head. Sam was shot through the top of his left shoulder. He then went back to a saloon on Pine Street and Third Avenue and informed the bartender that he had killed a man and for him to call the police station. He did and Peter Ryan was sent down and he brought Sam in. Sam was searched, two guns were found on him, he was then locked up, but claimed he had to do it in self-defense. The officers then went down to the G.N. tracks and found Pete dead with the revolver in his hand. Sam's case was continued from time to time and after nearly a year, was cleared on the grounds of self-defense. He was around Hibbing for a couple of months, then he was supposed to have gone to the old country and that was the last that I ever heard of him. About a year later, Mr. Norton got permission from Hon. Martin Hughes, as he was the trial judge, to withdraw the revolvers and send them to me as a remembrance of the only known dual fought in the state at that time.

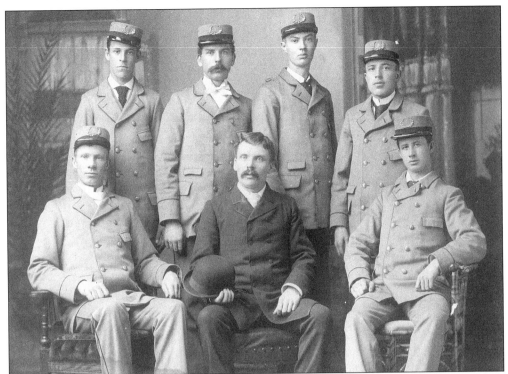

The first fire department was organized in the summer of 1894 with R.F. Berdie as the first fire chief. Opportunity to buy fire-fighting apparatus did not come about, however, until 1895. Until that the department was not much more than a "bucket brigade."

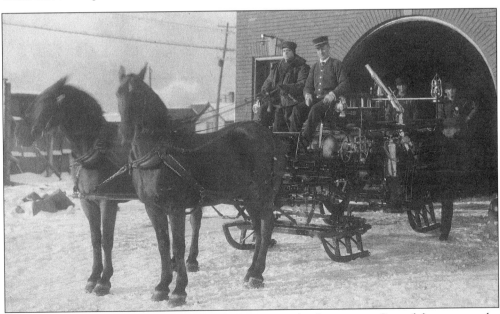

The men in this picture are backing their new rig into the fire station. One of the men on the wagon is Fred Loomis, and standing at the side is Chief McIllhardy. The horses were trained to walk right in to their rigging as it was lowered from the ceiling.

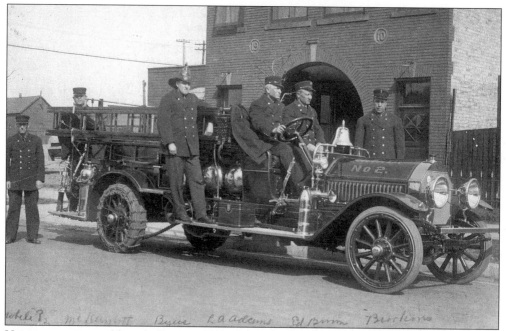

Horses were not used long before more efficient means were found. This picture shows the No. 2 Fire Hall on Railroad Street in 1914. These men are, from left to right: (?) Mobele, (?) McDermott, (?) Byers, L. A. Adams, Ed Brown, and an unidentified man.

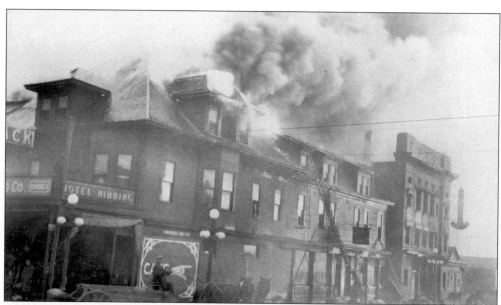

The Hibbing Hotel, which was located on the corner of Cedar Street and Third Avenue, and one of the classiest on "the Range," caught fire in 1915. The hotel was established by Frank Hibbing, but was not the only business started by the great man. He also owned the first bank, the Bank of Hibbing, and along with Mr. Trimble, started the first Hibbing Light and Water Co. Not long after, Hibbing and Trimble purchased bonds from the village to enable the village to purchase the Hibbing Light and Water Co.

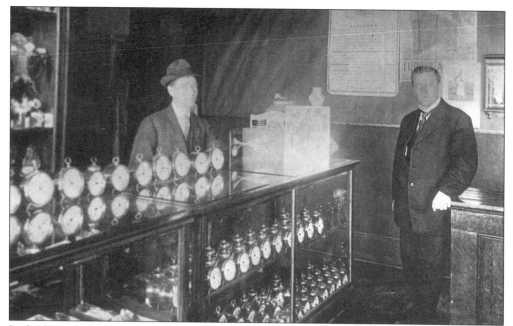

Right from the beginning, Hibbing had many different types of shops, stores, and dealers of all kinds. This is a photo of the Wuopio Jewelry Store, c. 1915. The men in photo, from left to right, are E. Kilkkinen and Henry Wuopio. From the advertisements on the wall of the store, it seems as though one could purchase a ticket for passage on a steamship to Europe.

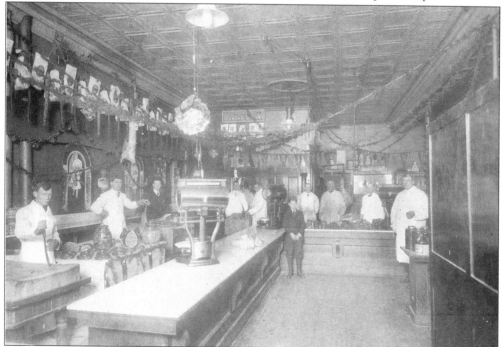

This picture was taken at Christmas time in 1911, inside Messner Brothers Meat Market on Center Street. These gentleman from left to right, are: Ira Kritz, Joe Glasser, W. Murphy, Billy (?), Ernest Messner, F. Stevens, John Messner, Tony Kozak, and Jacob Messner.

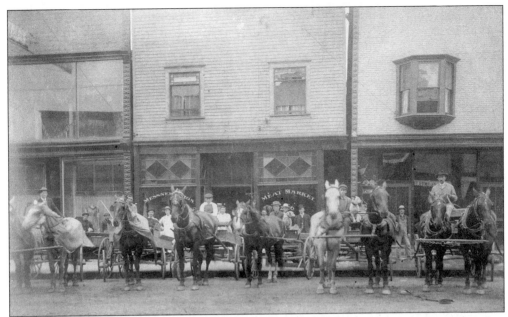

This outdoor shot of Messner Brothers Meat Market shows the delivery wagons used to cart groceries all over town. Because small iceboxes were used to store food, deliveries usually came about twice a week.

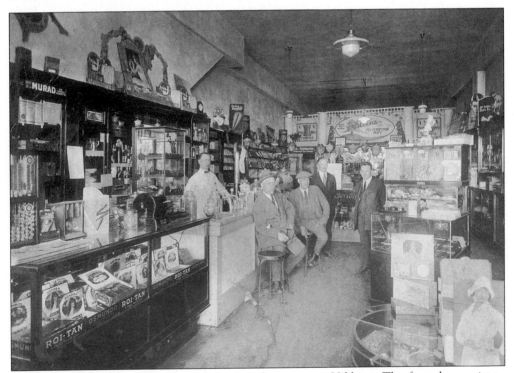

J.H. Carlson and J.O. Walker started the first drug store in Hibbing. The first pharmacist to open up shop in South Hibbing was Louis Stein, pictured here, on the far right. The other men are unidentified.

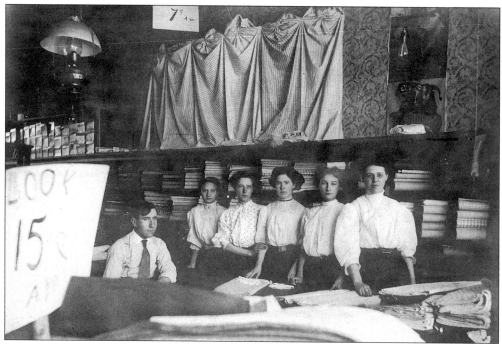

This is a photo of the Hibbing Department Store, located on Pine Street, in 1910. The gentleman is unidentified, but the ladies, from left to right, are: Susan Maki Stevens, Minnie Savela Maki, May Sullivan McCarthy, Lillie LaFrance, and Mrs. Shapiro.

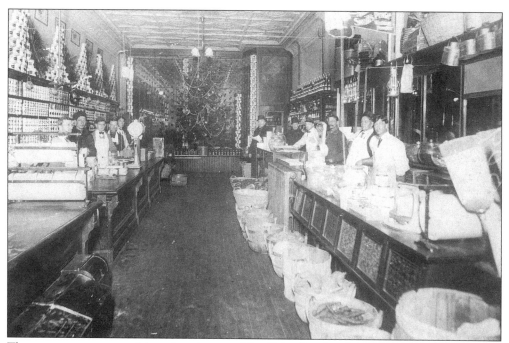

There were many successful markets in town. The Kohrt Brothers Market was started in 1902 by Herman A. Kohrt and Christian Frederick Kohrt. Seen here in 1904, they have also decorated for the holidays. They even have the coffee cans arranged to look like Christmas trees.

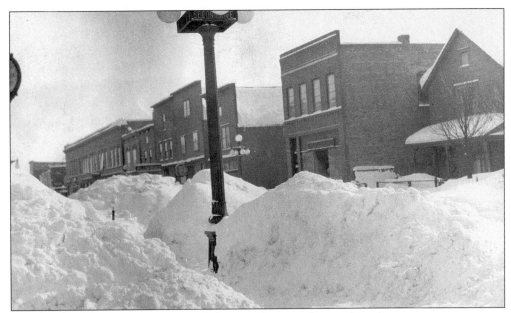

Being in northern Minnesota, people have to learn to live and work in some pretty snowy conditions. This photo, taken in February of 1916, shows the huge snowbanks on Center Street between Second and Third Avenues.

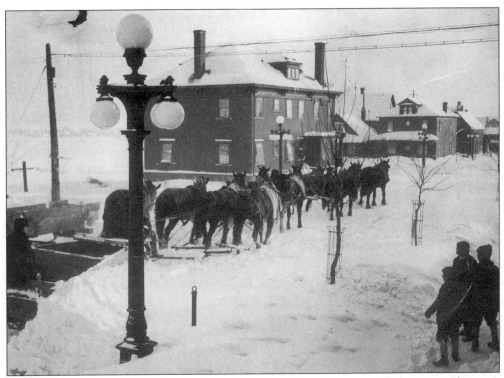

In the days before the power driven plows, horses would have to move all the snow. The snow was very heavy, so very large teams of horses had to be used. This group of young boys stop to watch the impressive team as it makes its way down the snow-filled street.

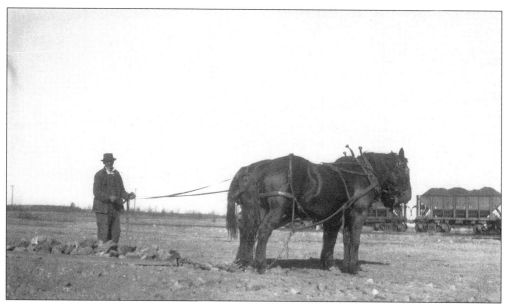

Tasks for horses were endless. They plowed snow and pulled the paddy wagon and the fire wagon. They worked on farms and in the mines. The man in this picture is using his team to pick up rocks from a local mining company's grounds.

Children had their fair share of the workload too. This photo shows two boys tending to the large garden tract that was located on Third Avenue. The boys in this 1918 photograph are unidentified.

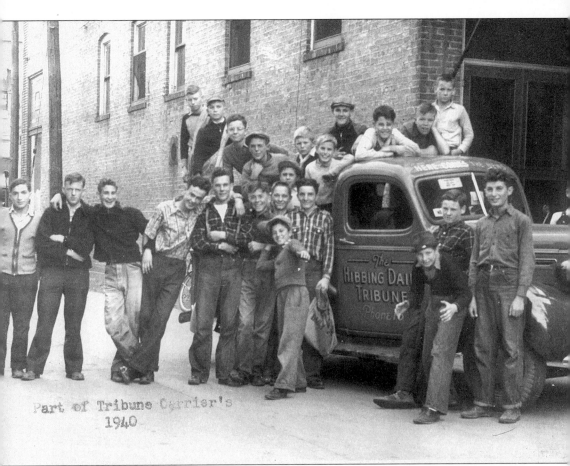

Part of Tribune Carrier's
1940

This happy bunch of kids posing for the camera represent just part of the *Hibbing Daily Tribune*'s newspaper carriers for the year 1940. In the beginning, there were two major newspapers in town. The first one was published as the *Hibbing News*, from January 19, 1894, to April 19, 1902. It had started in Mountain Iron, but was moved to Hibbing in 1899. That became the *Mesaba Ore* and the *Hibbing News* from April 26, 1902, until January 30, 1920. On February 2, 1920, it became *Hibbing Daily News* and the *Mesaba Ore* until December 22, 1922. The next day, December 23, it became *Hibbing Daily News* and stayed that way until December 2, 1927. After that, it became part of the *Hibbing Daily Tribune*. The *Hibbing Tribune* was started on July 1, 1899, and lasted until February 19, 1910. On February 21, it became the *Hibbing Daily Tribune*. Today the paper is simply called *The Daily Tribune*.

Three
LOCATION, LOCATION, LOCATION

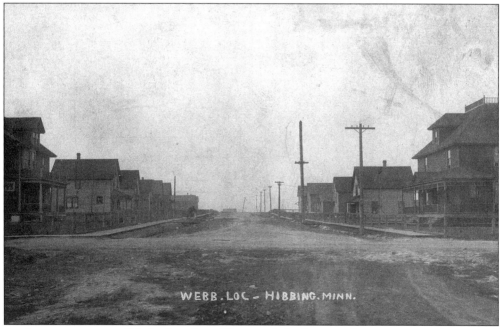

WEBB.LOC – HIBBING.MINN.

As the town grew, so did the locations. Tents and shacks started to give way to houses and gardens and power lines. This photo of Webb Location shows the nice wide streets and wooden sidewalks. This photo was taken *c.* 1910.

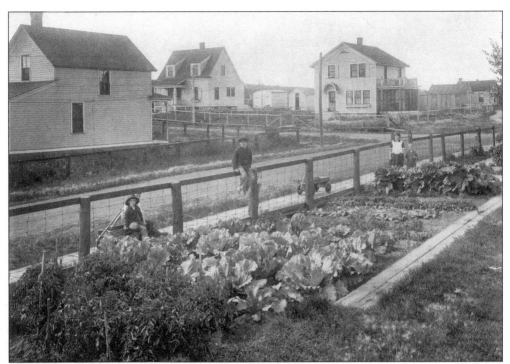

It was very common for the family garden to take up much of the space of the yard. These children pose by the Lian family garden at Morris Location.

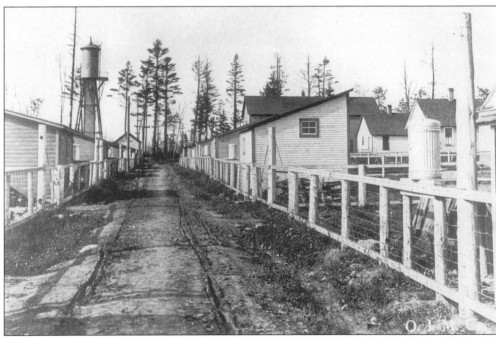

This is a photo of an alley in a Hibbing mining location. It is not known which location, but it is a very typical view of how the location alleys looked. Alleys were then, as now, the Main Streets of the youngest generations.

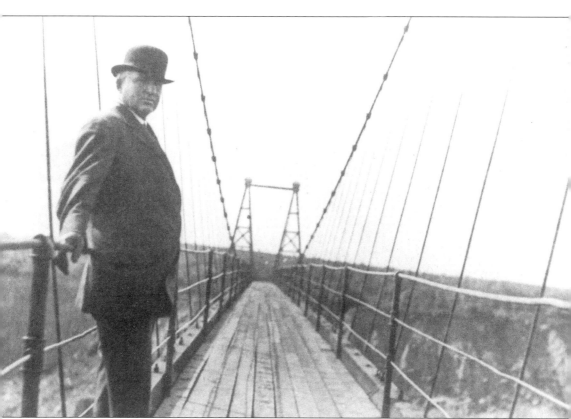

As the mines endlessly chewed away the earth, some locations became somewhat isolated. In many cases, suspension bridges would have to be built to connect the locations to other communities or to the mines themselves. The gentleman in this picture is unidentified, but the bridge was in Stevenson Location.

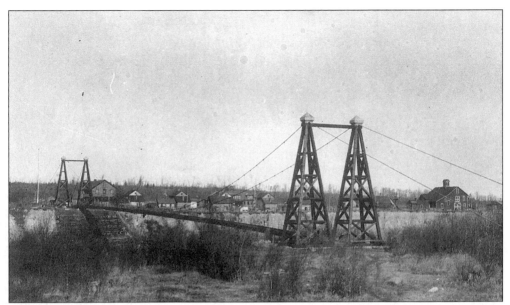

This is another look at the Stevenson Bridge. Built across the mine at an expanse of 500 feet, one can imagine how difficult it was to cross on extremely windy days.

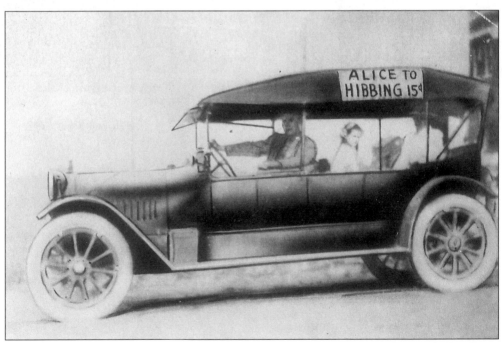

With locations being outside the immediate village and sometimes isolated, some form of mass transportation had to be developed. This photo is of the 1914 hupmobile. One way between Alice and Hibbing was 15¢, round trip, two bits. Believe it or not, this vehicle is the ancestor of the great Greyhound bus lines that run today. (Courtesy of the Greyhound Bus Origin Museum, Hibbing, Mn.)

42

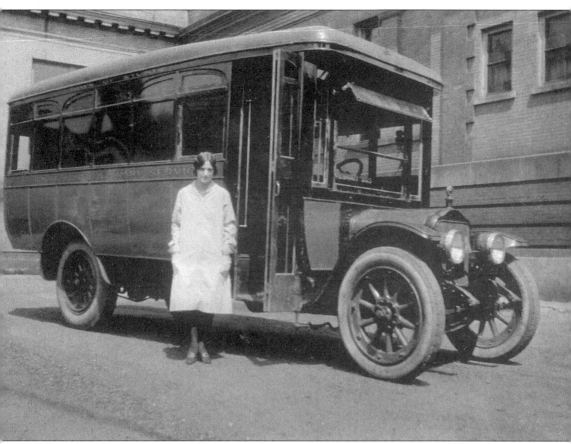

One way that the locations were not isolated was by the weekly stop of the library bus. This library bus, the first of its kind in the country, would bring books for the many different languages and ages of the readers to schools and farmhouses alike. The idea for the bus came from librarian Dorothy Hulbert, but the first traveling librarian was Charlotte Clark. "The Bus Lady," as she was affectionately known, poses for this picture, c. 1920.

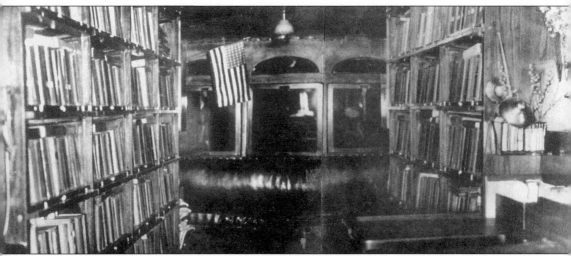

The interior of the bus was large enough to allow six people to look for books at one time. The shelves had sliding glass doors, to keep the books from falling off over bumpy terrain, and could hold as many as 1,000 books. Adult books were kept on the right, children's on the left, and the magazines in the back.

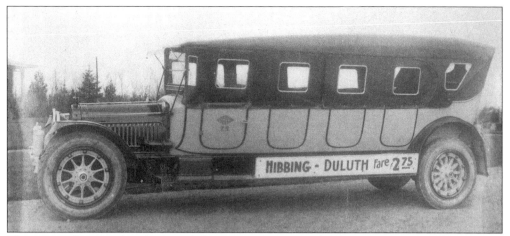

This is a photograph of one of the 15-passenger Packard sedans run by the Mesaba Transportation Company, which would later become Greyhound. They took passengers between Hibbing and Duluth for a fare of $2.75. One way took about three and a half hours.

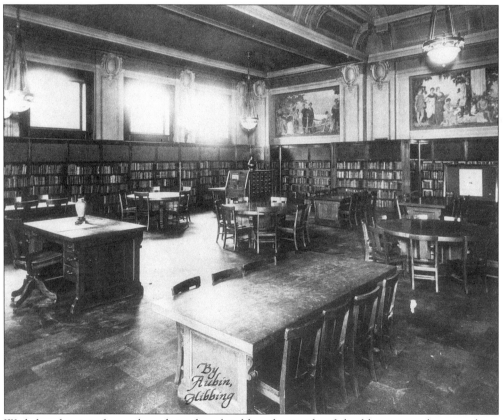

With hand-painted murals and sturdy oak tables, the inside of the library was also something to see. This lovely structure was one of the last to stand and function in North Hibbing, its place being taken by a more modern structure in South Hibbing in 1953. Though the Carnegie Library no longer exists, the incredible murals that adorned the walls were saved and can be viewed in various buildings around town.

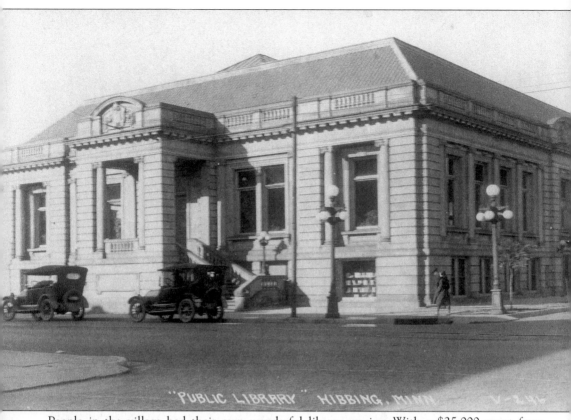

"PUBLIC LIBRARY" HIBBING, MINN. V-246

People in the village had their own wonderful library service. With a $25,000 grant from Andrew Carnegie, this beautiful little building was constructed. Work began on the pink sandstone structure in 1907, and it received remodeling and an addition in 1915, at a cost of $130,000. This picture shows the library as it looked after the remodeling.

Four

FUN TIMES

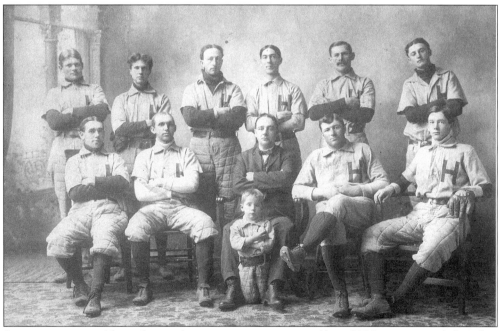

Sports are now, and have forever been, an important part of how Hibbingites spend their free time. This is the Hibbing Baseball Club Champion Independent Team of Northern Minnesota, known as Brady's Colts, in 1904. They are, from left to right: (front row) Geiselman—center field; Austin (capt.)—2nd base; T.F. Brady—manager; Meisner—right field; Dwyer—left field; (back row) Kleffman—3rd base; Calligan—short stop; Freeman—pitcher; Symons—pitcher; Kleffman—catcher; Metcalf—1st base. The mascot is T.F. Brady Jr.

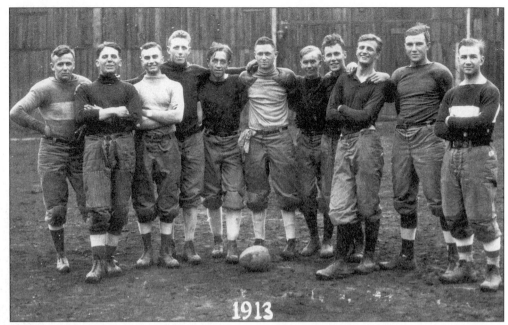

In this photo, taken in the ballpark behind the Oliver Hotel in North Hibbing, we catch a group of young men playing football in the mud. From left to right, they are: Percy Webster, Fred Cobb, Bill Schirmer, Percy Baker, Jack Adams, Galen (Barney) Finnegan, Bill Hooker, Paul Swanson, Dell St. Julien, Howard Reusswig, and Charles Bardessono. This photo was taken in 1911 or 1913.

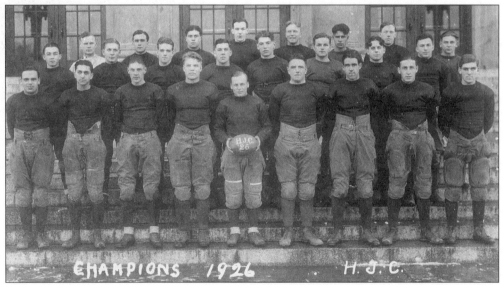

Playing for the Hibbing Junior College, these fellows pose for their 1926 Championship picture. From left to right, they are: (front row) unidentified, Miram Markell, unidentified, Lumpa Schmidt, unidentified, unidentified, Alex Cameron, Neil Schurman, and Wilbur Cheever; (middle row) unidentified, unidentified, unidentified, Wayne Sword, Eddie Potrasky, unidentified, unidentified, Morris Keth; (back row) Coach Saraga, Merrin Mischaud, Frank Anglissi, Erwin Everett, Anstin Wilson, Frank Tracy, Billie Burk, Ellis (?).

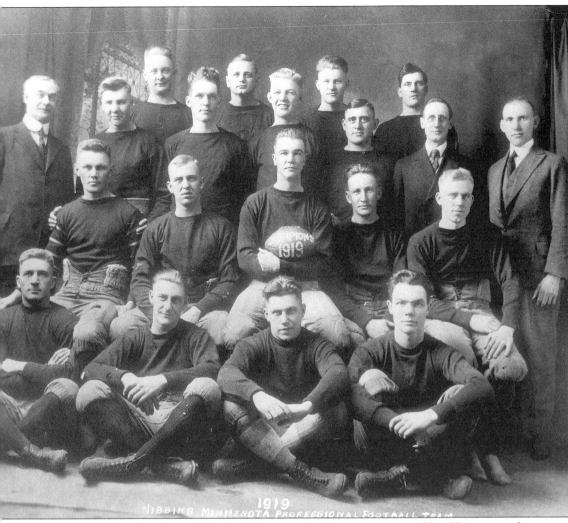

1919
HIBBING MINNESOTA PROFESSIONAL FOOTBALL TEAM

In 1923, the Hibbing Professional Football Team, under the management of Ray Kreis, opened the season with the first game to be played against the Green Bay Packers in their new stadium. The lineup for Hibbing included L. Marshall, Turnquist, Sullivan, Rundquist, Burkeman, Buland, Underwood, Ursella, Rooney, Zgonc, and Beasy. The line up for Green Bay was Wheller, Buck, Kenyon, Nelmann, Gardner, Earps, Lyle, Mathys, Mills, Lambeau, and Gavin. The Hibbing Professionals were beaten by a score of 10 to 0. This is a photograph of the team in 1919.

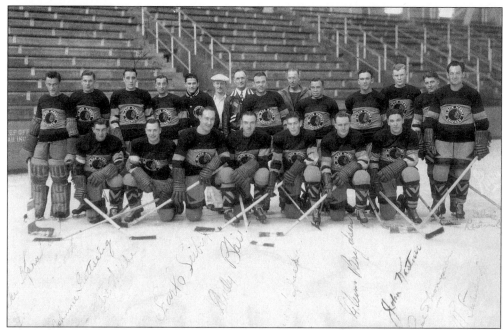

The Packers are not the only outside professional sports team affiliated with Hibbing. The Chicago Blackhawks hockey team used the Memorial Building Arena for practice purposes. This picture is of most of the players on the 1936-37 team.

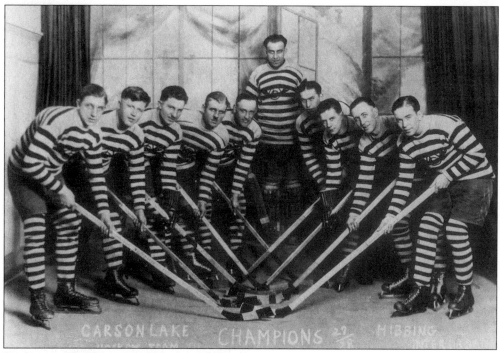

Hockey is a favorite sport of the local folks. The Carson Lake Hockey Team was the 1927-28 Interurban Champions. From left to right, they are: Rudy Maras, Bill Zbacnik, Harold Horn, Mel Hall, Clarence Patterson, Harold Kelly, Mike Marinac, Elmer Ahlstrom, Geo Kelly, and Bill Kelly.

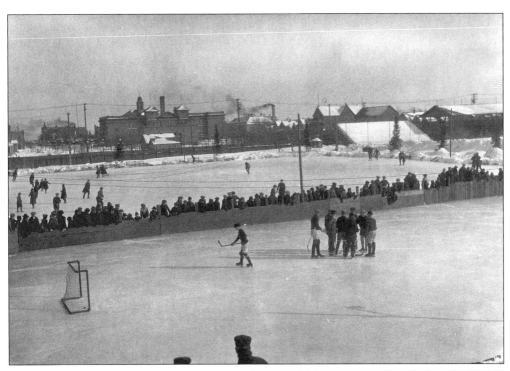

At just about every school and every location, one would find busy ice rinks of all sizes. These are the skating and hockey rinks behind the Washington and Jefferson schools in North Hibbing in 1922.

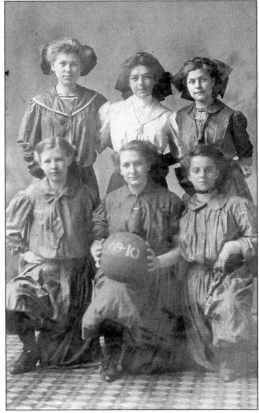

Posing for this picture is the girls basketball team for 1909-1910. From left to right, (front row) they are: Beatrice Atkinson, Phena Bay, and Lillian Keifer; (back row) Ada Ryder, Dorothy Cohen, and Signa Eckstrom.

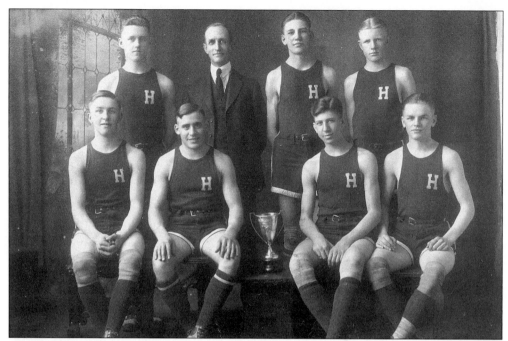

This photo was taken in 1921 when the boys basketball team won the district championship. The team went on to play in the state tournament in Northfield where they were beaten by New Ulm in the quarterfinals, but were awarded the Sportsmanship Trophy for "Best Conduct and Appearance." From left to right, (front row) they are: Alton Nord, Al Sonaglia, Ernest Messner, and Frank Burkman; (back row) Neil Jarvi, Coach Walter McMillan, Angelo "Boots" Taveggia, and Ted Anderson.

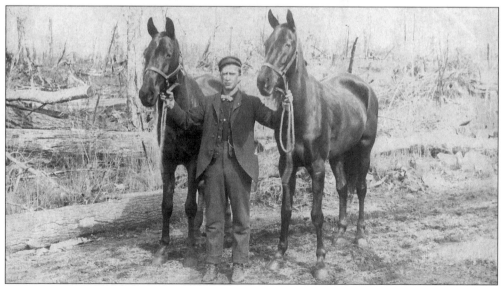

Racing of all kinds has always been a popular pastime in Hibbing. The fairgrounds, first in Pool Location and then in South Hibbing, had large oval tracks for various forms of racing. Many people in town owned their own racehorses. Fred Twitchell had two and so did Albert H. Powers, who is posing with them for this picture in 1905. The horses' names are Albert and Lucy.

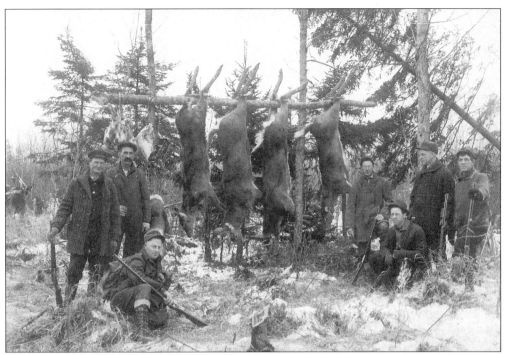

Hunting is almost as big today as it was in the early years. Shown here are some Stevenson Location deer hunters in 1918. From left to right, they are: Ed Peiton, Gene Gassolin, Carl Allison, Ed Cochron, Elmer Harrison, Clyde Harrison, and Mel Harrison.

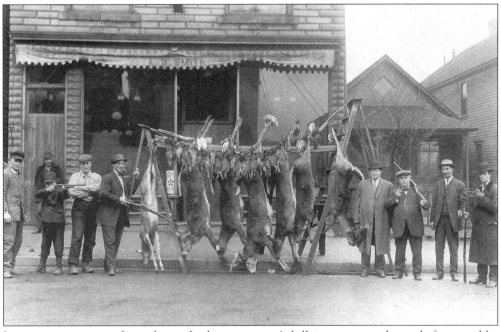

It was once very popular to bring the hunting party's kill into town and pose before a public establishment. Often, the party would take birds and rabbits as well as deer. This photo, taken c. 1915, was shot in front of the Shamrock Saloon.

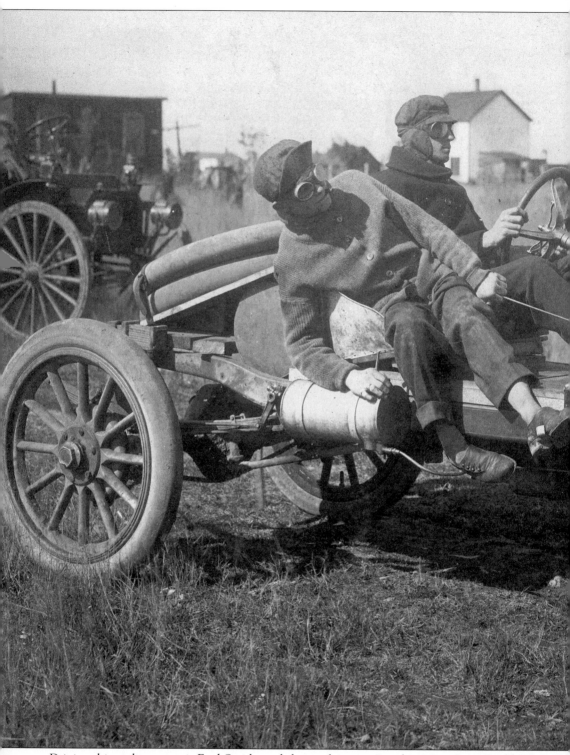

Driving this early racecar is Fred Smith, and the co-driver or "mechanic" is Oscar Rudd. The job of the mechanic was to operate the auxiliary fuel pump and to help lean into the curves to

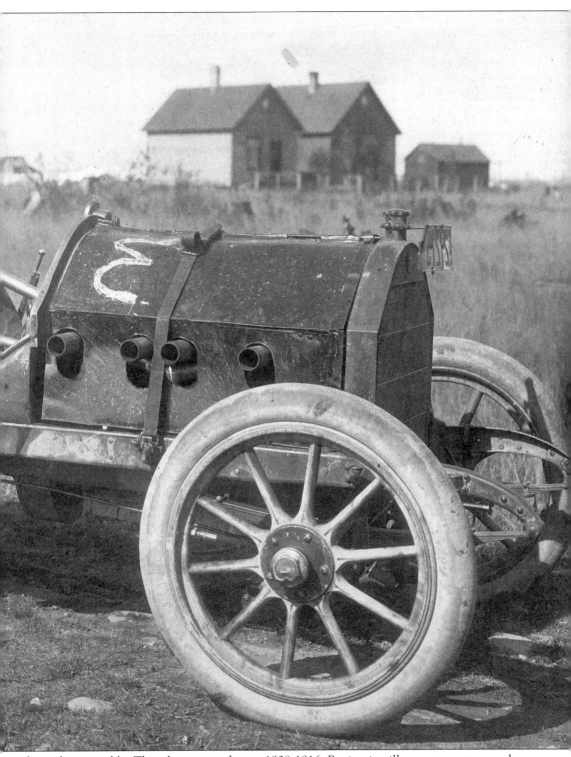

keep the car stable. This photo was taken *c.* 1908-1916. Racing is still a great way to spend a
Saturday evening in town.

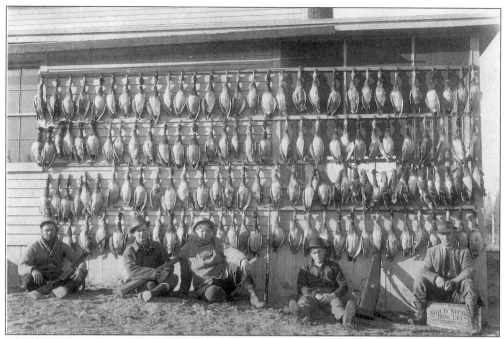

These gentlemen are taking a rest after a long day duck hunting. With 129 ducks, it was a very successful day. The hunters, from left to right, are: Fred Hawkins, unknown, Percy O'Hern, Dan Haywards, and Geo E. Scott.

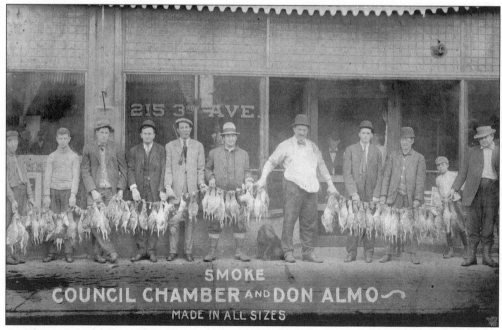

Another successful hunt, this time for grouse. The men in this picture, from left to right are: unidentified, unidentified, B.J. Burrows, M ike Sommers, Lester (?), W.J. Rezac, Jake Messner, Guslman's father (in window), (?) Guslman (in window), Charley Calligan, Geo Scott, unidentified, and Victor Power.

Boxing was a sport of great interest to many people of Hibbing. This little fellow was a very popular fighter. He was known as Fighting Pal Brown and weighed in at only 130 pounds. The inset in this photo is of his manager, Dr. Plapper.

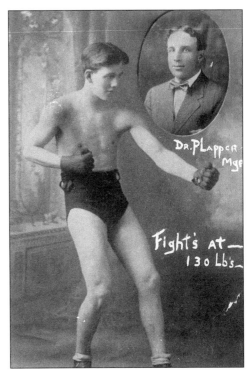

On August 21, 1901, a fight was scheduled between local fighter James Arnold and Jack Beauscholte, who was a popular Chicago boxer, by Fred Twitchell and the Hibbing Athletic Club for the fireman's convention taking place that week. The bout was contested by a local clergyman who, through Governor Van Sant, was able to get the local sheriff to stop it after the first round. During the night, the match was simply moved across the county line into Itasca County. In the woods, a crude ring was set up and the next morning the fight, refereed by John Madden, lasted 15 rounds and ended in a draw.

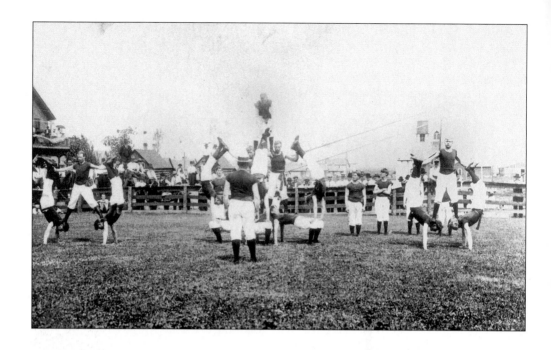

Though you will not find the men of today's Hibbing engaging in the art of gymnastics, in yesteryear-year you would find just that and large crowds would come to watch the display. These photographs illustrate the complicated maneuvers, strength, and agility possessed by the Stevenson Location Drill Team.

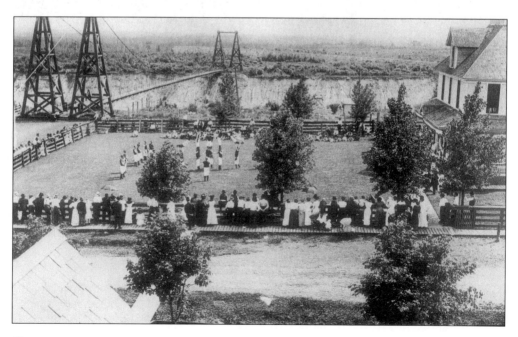

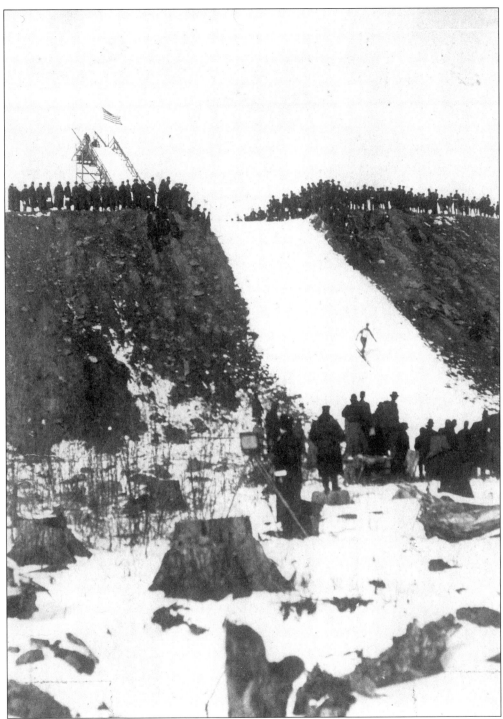

Another big crowd pleaser was ski-jumping. The "dumps," as they're known locally, are basically hills of surface material and scrap iron ore left over by the mining companies. These dumps provided excellent places to install ski jumps. The jump in this picture was located at the South Agnew dumps. Hibbing's last ski jump was located where Highland Drive is located now.

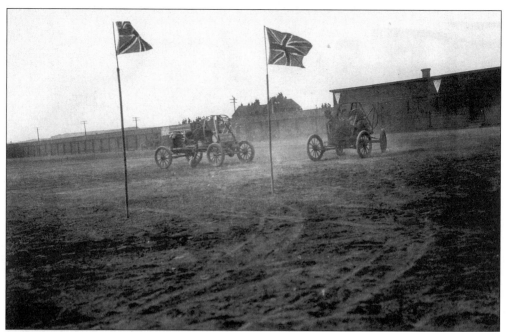

Racing was not the only sport that cars were used for in this town. This photo, taken on the morning of Sunday, August 15, 1915 at the Hibbing Ball Park, depicts a game of, believe it or not, Auto Polo. Notice the man on the left reaching for the ball.

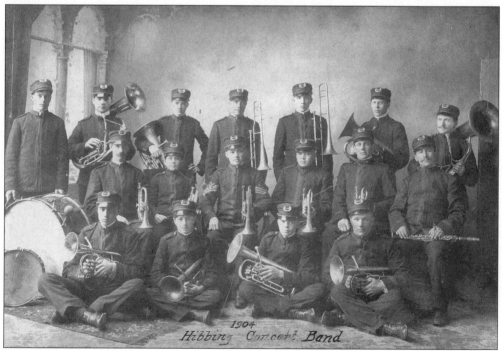

Probably the most enduring form of entertainment in the town is the Hibbing Concert Band. This award-winning band is still going strong today. This is the Hibbing Concert Band of 1904. The director at this time was William Ahola.

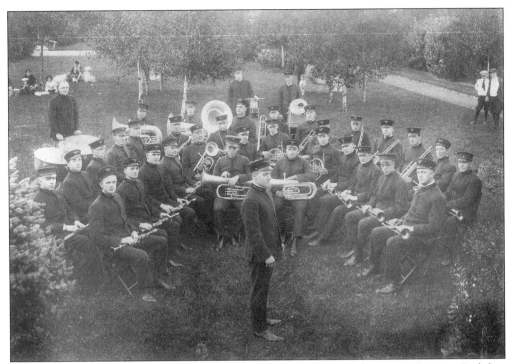

The Hibbing Concert Band practices and performs in a variety of locations. Bennett Park has always provided a wonderful setting to sit and enjoy the talented band members' performances. This is the Hibbing Concert Band of 1914, with Frank Solazzi as its director.

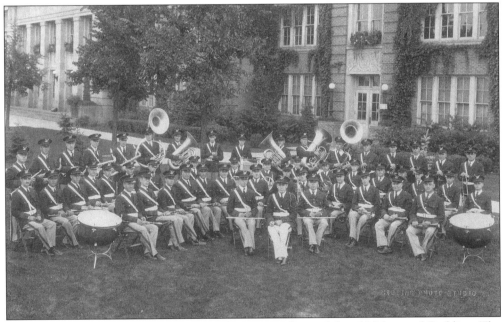

In 1931, the band poses for the camera, this time in front of the old Memorial Building. The director was H.A. Frankson. In 1933, the building would burn to the ground and the band would become the State Band Champions.

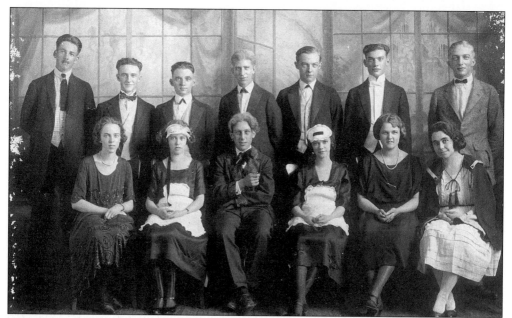

Plays are a great form of creative entertainment. These high school Glee Club members had parts in the Junior College students' production of *H.M.S. Pinafore* in 1922. The light opera had 68 characters, and was directed by E.P.T. Larson. Some of the ladies and gentlemen shown here include Ingrid Gunderson, Agnes Samuels, Reed Schoonover, Ernest Messner, and Fred Bruce.

Dramatic and comedic acting is not only for high school students, and could always be found in theaters and clubhouses around town. It is not known what play these actors were putting on, however, it took place at the Finnish Workers' Hall not long after the hall was rebuilt on Lincoln Street in 1906.

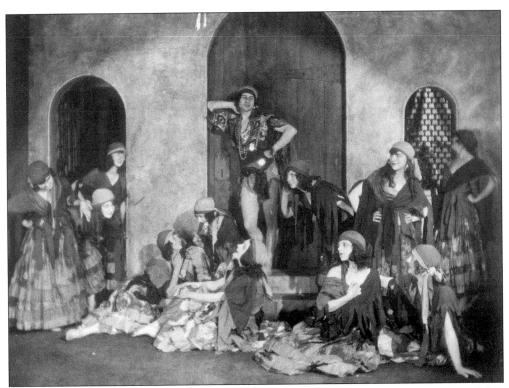

Once a cultural arts center, Hibbing had many famous acts of the day come to town to perform. Many of these performances were sponsored by the YWCA. This photo is of the Pavley–Oukrainsky Ballet, Manhattan Opera Company of New York, with Andreas Pavley posing in the doorway.

On Monday, October 27, 1924, John Philip Sousa and his world famous band performed two shows in the Hibbing High School auditorium. Bob Dylan also performed on this same stage, although at that time he was a student there, named Robert Zimmerman, and would not become world famous until much later.

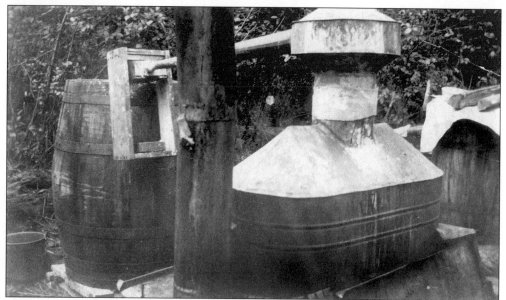

Probably one of the most common, though not most respected, diversions was drinking. Starting as the town did, as a lumber and mining camp, people would work hard and play hard, and Prohibition did little to stop it. "Moonshining" or "bootlegging" took place everywhere. The stills were found deep in the woods, but the booze was always underfoot, sometimes literally, for people buried jugs everywhere, including under alleys. This picture is of a still in Pool Location.

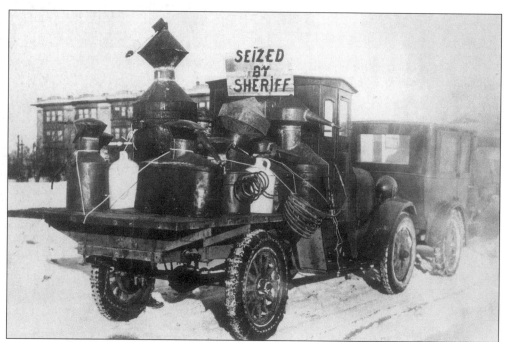

This picture, taken in 1920, shows a truck loaded with stills and other wine-making equipment that had been seized by the sheriff. The sheriff and the police department were busy indeed. The stories of the days when gangsters (some well known) tried to run the town, still abound.

Five

PLACES OF WORSHIP
AND LEARNING

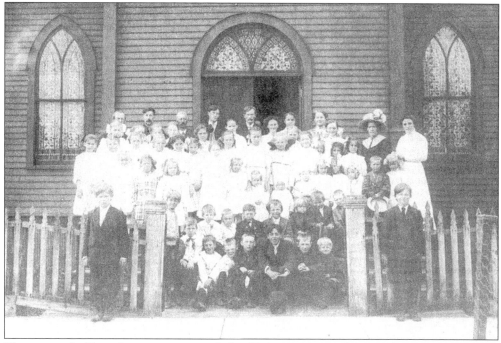

The primarily Finnish congregation of the Holy Trinity Lutheran Church was officially organized on June 8, 1896, under the name *Itsenainen Suomalainen Evankeelis Seurakunta*, meaning: Independent Finnish Evangelical Church. This picture from the old North Hibbing church shows the Sunday School class of 1908. This building was sold to the mining companies in 1939, but the church continues its work in a beautiful little stone building in South Hibbing.

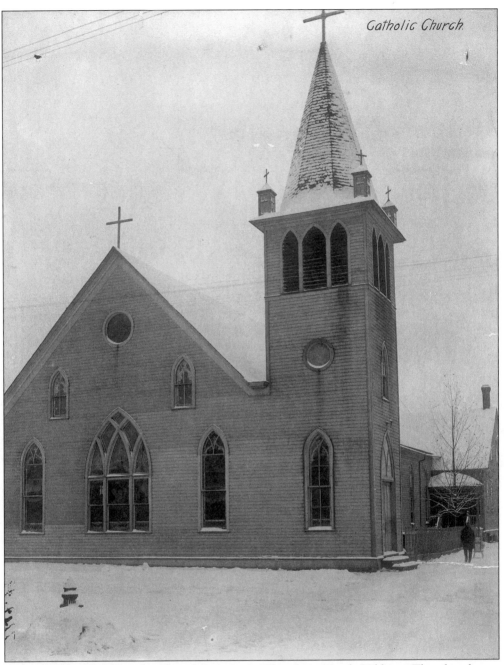

Catholic Church.

This Catholic church is the Blessed Sacrament Church in North Hibbing. The church was built in 1897, and held its first mass on September 19th. It was blessed on November 21, 1900, and acquired its first resident pastor, Father C.V. Gamache, in 1901.

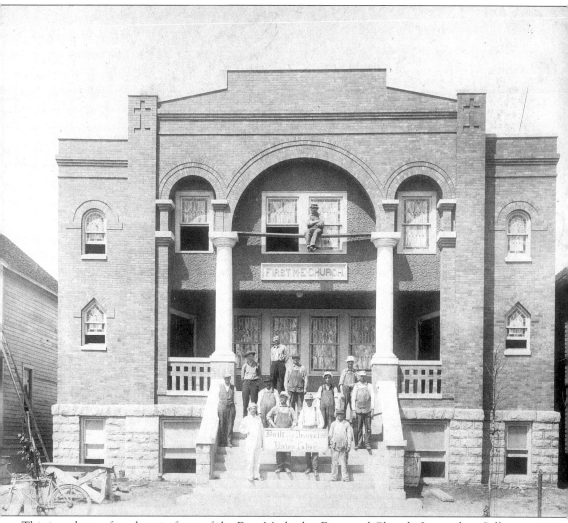

This is a photo of workers in front of the First Methodist Episcopal Church. Located on Sellers Street in North Hibbing, it was Hibbing's largest church building. The workers are holding up a sign that reads, "Built and Decorated by Union Labor."

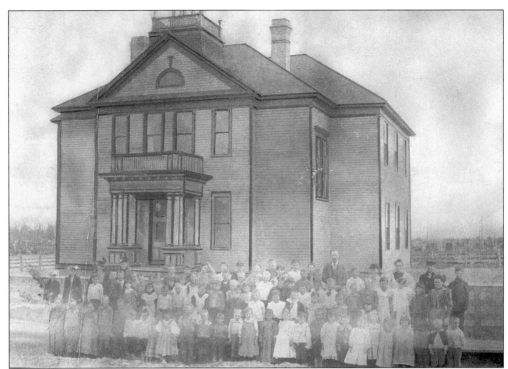

Hibbing's educational history started in January of 1894, when Miss Susan Murphy started teaching school on the second floor of the J.B. Carlson general store, located on Pine Street between First and Second Avenues. Some of the first pupils were William Bruce, Caroline Snyder, Julia and James Champion, Hale Cobb, and D.D. Haley. George Cobb also insisted on attending, although he was only three years old. This picture is of the first actual school building in 1896. The school was located on the east end of Center Street.

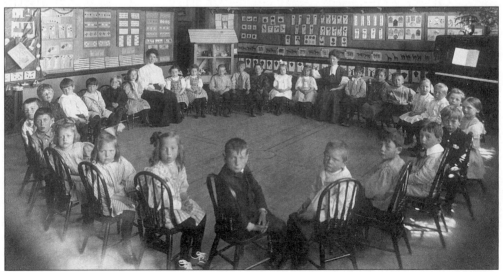

At the time that the Center Street School was built, the enrollment fluctuated between 14 and 21 students. The four-room schoolhouse was not immediately finished, as it was thought that the upper floor would not be needed right away. This thought would prove to be completely wrong.

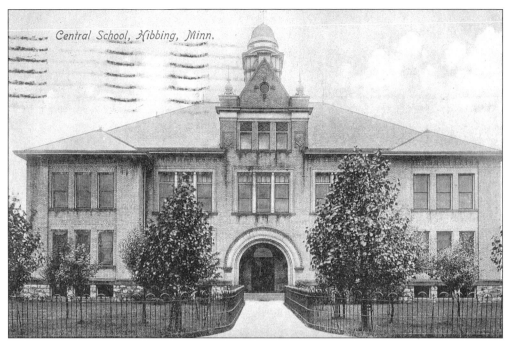

Central School, Hibbing, Minn.

By the summer of 1896, the enrollment had risen to 87. Two more rooms were added to the Center Street school, other buildings were rented, and in 1902, this impressive and very modern building went up on Third Avenue between Mahoning and Superior Streets as the first high school. Originally named the Central School, it would eventually become known as the Jefferson School.

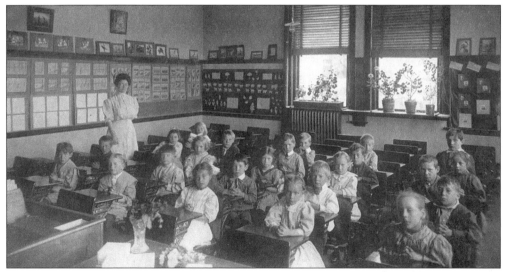

This photo of a Central School classroom was taken in 1908. The teacher is Miss Davis and the students are, starting at the far right: (row 1) Viola Ankenbrand, unidentified, unidentified, Hazel Sullivan, unidentified; (row 2) all unidentified; (row 3) Margaret Remington, (?) Greiniger, Meriam Godfrey, Geo Graham, Elsworth Woods; (row 4) (?) Ryder, James Newcombe, Milly Nord, Albert Swenson; (row 5) Steve Ryan, unidentified, unidentified, unidentified, unidentified.

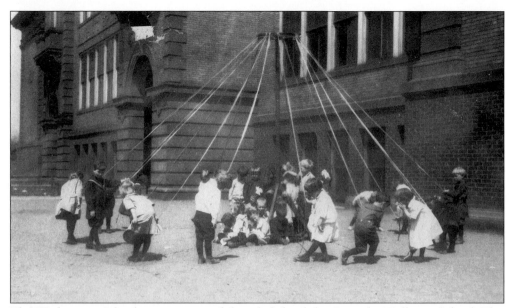

The Washington School was constructed directly behind the Central or Jefferson School. This photo, taken in 1915, shows Miss Edna Thurber's kindergarten class engaged in a Maypole dance.

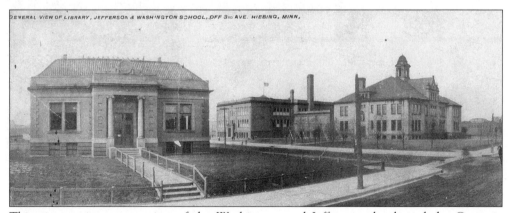

GENERAL VIEW OF LIBRARY, JEFFERSON & WASHINGTON SCHOOL, OFF 3RD AVE. HIEBING, MINN.

This picture gives one a view of the Washington and Jefferson schools and the Carnegie Library. This picture looks north on Third Avenue and across Mahoning Street, which separates the schools and the library, c. 1910.

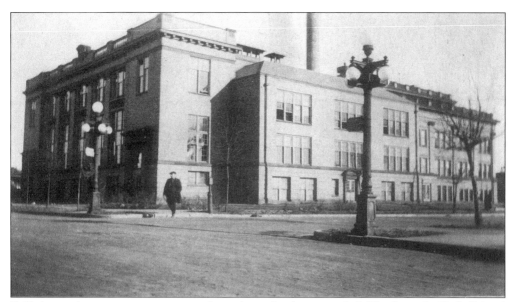

Still the students were pouring in and another school was needed. The Lincoln High School was constructed in 1907, between Lincoln Street and Washington Street, and the freshmen through senior classes were transferred yet again.

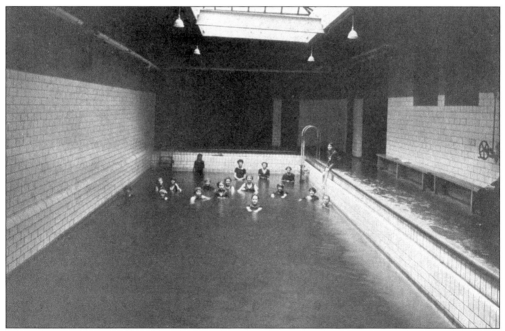

The Lincoln High School may have been one of the very first in the country to house an indoor swimming pool. The exact date that it was put in is not known, but this image of it comes from the 1914 yearbook. The schools also had many other things to offer students, including the services of two full-time nurses, a doctor, and a dentist.

The locations also had to have schools. Here we see the Leetonia Location schoolhouse. This photograph was taken in 1915. It was very typical of a location school. Though Leetonia Location itself is still in existence, the school is gone.

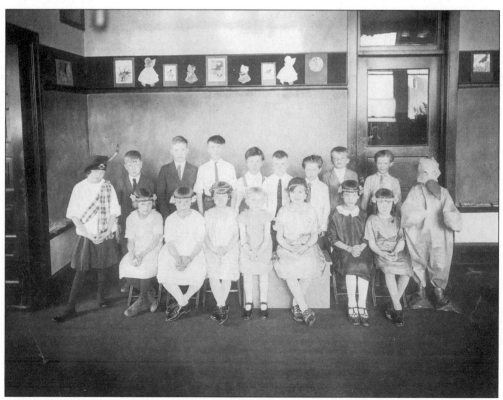

Taken in 1925 or 1926, this picture is of the second or third grade class of the Carson Lake School. They seem to be dressed up for some sort of play or production. It is difficult to picture someone dressing as a duck for school on a regular basis!

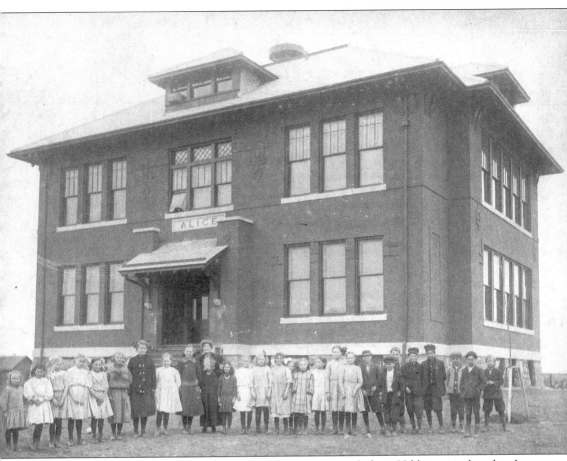

The Alice School, seen here in 1912, was built in the center of where Hibbing stands today. It had a residence for teachers on its top floor. This beloved old school was to last many years until its fate was sealed in 1979, as all efforts to save the building from demolition were lost. The spot where it stood is now a parking lot.

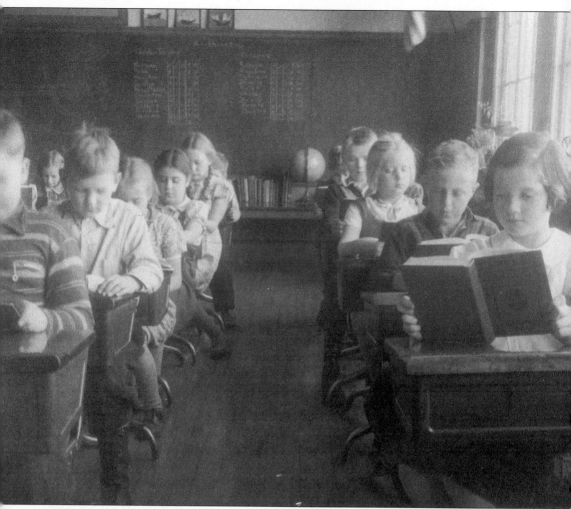

This photo was taken of Marion Ward's fifth grade class for the 1942-43 school year. From left to right, they are: unidentified, Charlotte Magnussen, unidentified, unidentified, Rose Ann Sher, Mary Ann Munter, unidentified, unidentified, David Ryan, Mary Ann Seppa, unidentified, and Mary McCardy.

Six

GOIN' SOUTH

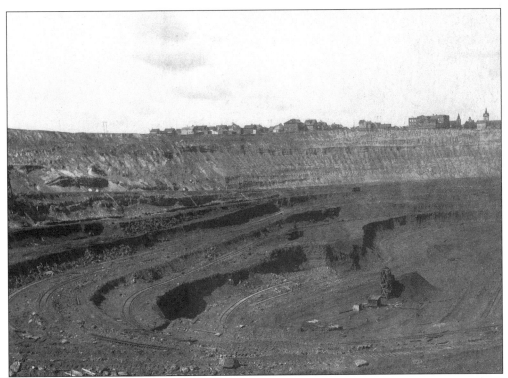

The great mines kept creeping ever closer to the little town. Soon, Hibbing was on a peninsula in the heart of the mines. This photograph shows how the buildings of the town were literally perched on the edge of the mines. It became quite apparent that Hibbing was going to have to move.

Victor Power was the first village president to really stand up to the mining companies and place control of the town where it belonged: with the people. It wasn't hard for him. As a lawyer, Mr. Power had been battling with mining companies in the interest of local citizens for years, so when this great man moved his offices to South Hibbing, the bulk of the population began to follow.

Victor Power had managed to get enough tax money out of the increasingly rich mining companies to pave and light the streets in town and extend the water and sewers. These were amenities that many cities of much larger sizes could not boast. Even with all the improvements, the benefits of moving south could not be denied. In this picture, one can see how close together some of the houses were. Notice the street paved with small wooden blocks.

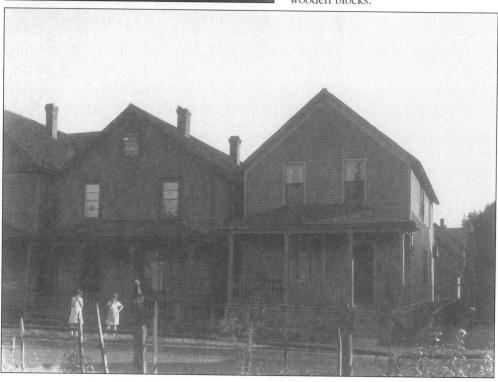

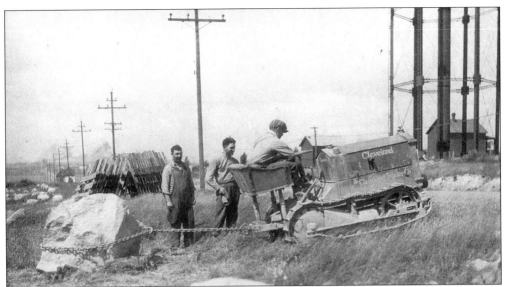

The moving of the town took place over many, many years. The first major move was starting in 1919. These fellows are using their Cleveland tractor to collect boulders for use in building foundations in Central Addition, South Hibbing on July 16, 1919.

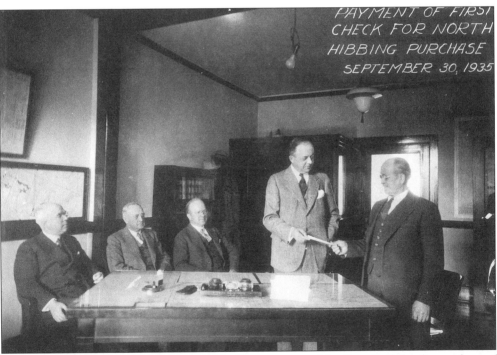

PAYMENT OF FIRST
CHECK FOR NORTH
HIBBING PURCHASE
SEPTEMBER 30, 1935

The second major move began in the 1930s. The payment of the first check for the purchase of a North Hibbing property occurred on September 30, 1935, at the Lake Superior Industrial Bureau in the First National Bank in Hibbing. This photo is of that transaction, and the men in the photo are, from left to right: Elmer Blu, William Chinn, Earl Hunner, Leroy Salsich (president of the Purchase Committee), and Adolph Eck. Eck was paid $2,500 for his property at 106 Washington Street.

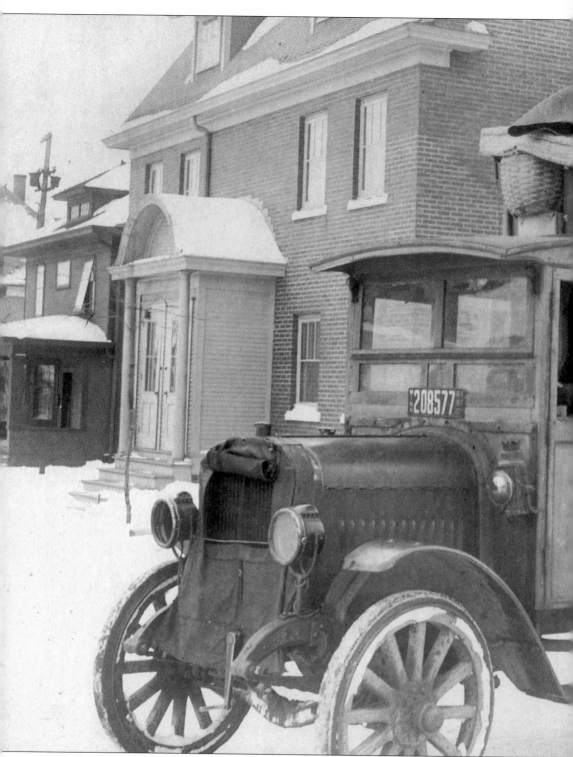

Right from the very beginning, Hibbing had its share of moving companies. Some companies moved belongings and some moved entire buildings. This photo shows a truck from the

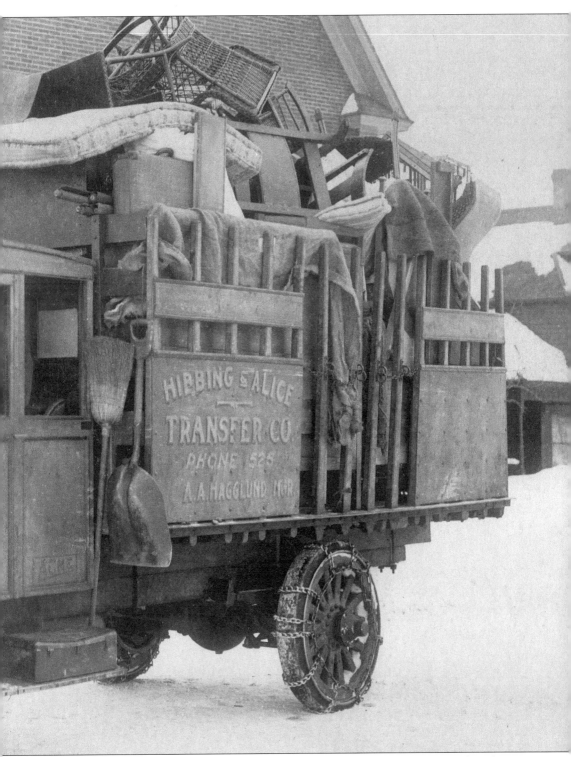

Hibbing & Alice Transfer Company, loaded up for its trip to South Hibbing. This photo is thought to be c. 1920.

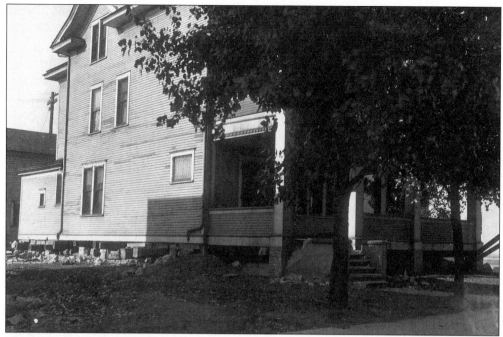

This is the Frank Dear residence located on Second Avenue and Superior Street preparing for its move south on September 11, 1919. The house has been jacked up and the foundation knocked out. The cribbing, or large timbers that the house will rest on in transport, was then set up.

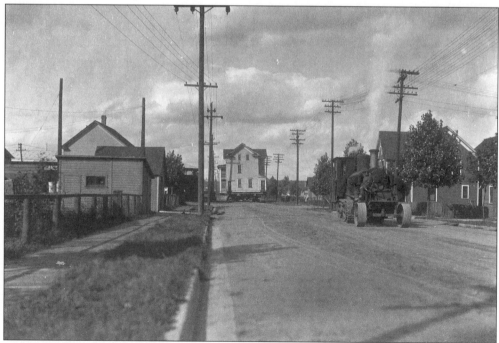

On September 16, 1919, the Dear home could be seen rolling down First Avenue. The steam tractor that was pulling it is seen driving away from the house. It must be lunch time.

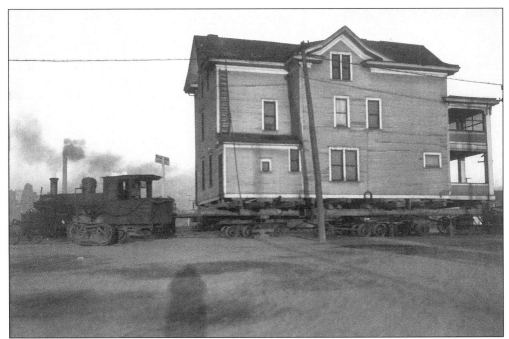

The Dear residence is now crossing the Duluth, Missabe & Northern railroad tracks at First Avenue. You'll notice that the house has had its chimney removed. That was for safety when being pulled under power lines. Many times, a man would ride on the top of the building with a forked stick to pick up the lines if there was not enough clearance.

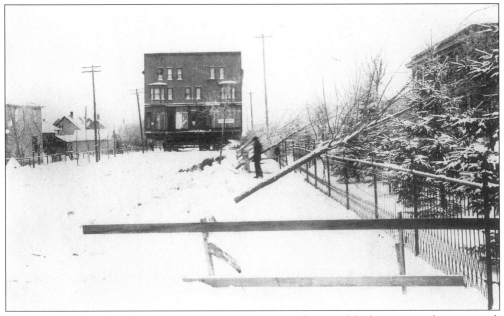

As we can see from this photo, sometimes it was not enough to modify the structure being moved. The landscape itself would have to change. These trees were partially dug up and tilted out of the way for the Oliver Iron Mining Company office building making its way down the road. After it passes, the trees could easily be put back in place as long as the taproots were not damaged.

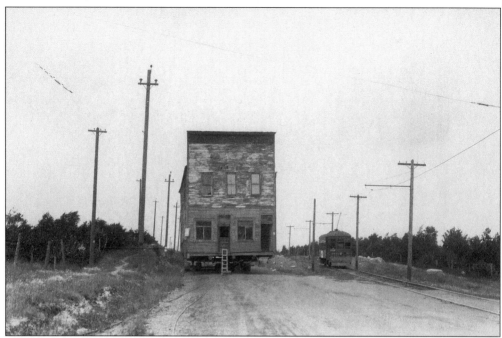

The ladder leading to the door of this building brings to mind a local story. In many cases, a family would continue to live in a building during its transport to South Hibbing. On one such occasion, a doctor drove to North Hibbing to assist in a complicated birth. The child was delivered the following morning in South Hibbing, and the doctor had to return north to retrieve his car.

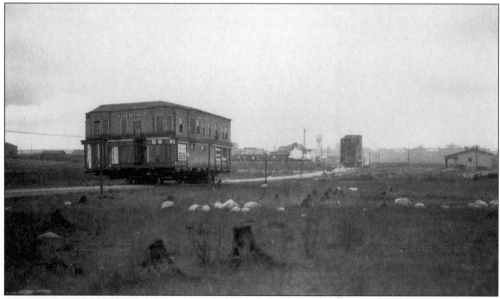

This is the Hibbing Hotel and the Arlington Hotel on November 4, 1921. The Hibbing Hotel was built by Frank Hibbing, and opened on February 22, 1896, with a grand ball. At the time it was built, it was considered the finest hotel north of Duluth, and people came from all over the range and Grand Rapids to celebrate in the festivities.

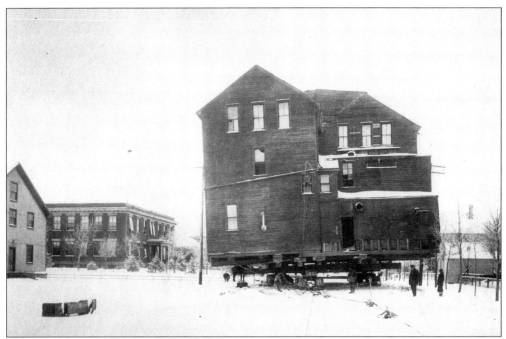

Although the vast majority of buildings made the trip quite safely, there were a few mishaps. This photo shows the Sellers Hotel just starting to list a little bit due to frost. Try as they might, the movers were not able to straighten her out and the building came crashing to the ground on January 3, 1921. The bright side of the story is that the building provided a lot of lumber to heat many homes over the winter.

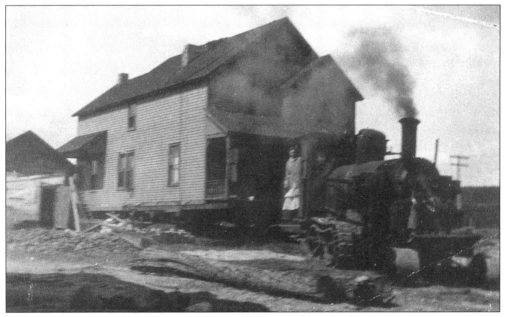

The steam crawler in this picture was driven all the way from the Day Lumber Company in Big Fork. Typical of steam tractors of the day, it took two people two operate it: one to steer and one to keep the wood burning and handle the throttles.

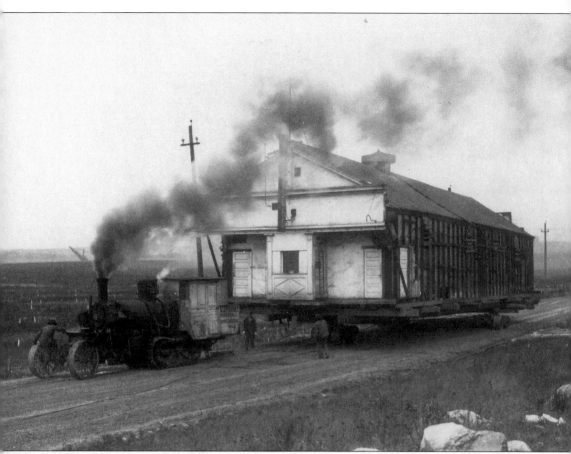

Taken on September 30, 1921, this photo shows the Princess Theatre being pulled south by a steam tractor. Periodically, the men would have to stop and inspect and sometimes adjust the load. Hibbing has had many theaters in its day. Though all of the old theaters are gone, a couple of the buildings they occupied still stand, including the Lybba, which was named after Lybba Edelstein, Bob Dylan's great-grandmother.

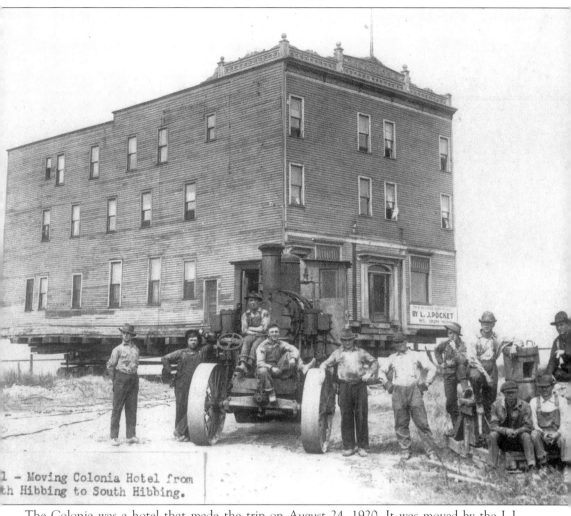

1 – Moving Colonia Hotel from
th Hibbing to South Hibbing.

The Colonia was a hotel that made the trip on August 24, 1920. It was moved by the L.J. Pocket Company all the way from Mountain Iron. Over the course of its lifetime, this building had many owners and served many purposes, including having a roller rink on its first floor from 1909 until 1913, and becoming a boarding house for teachers in 1924.

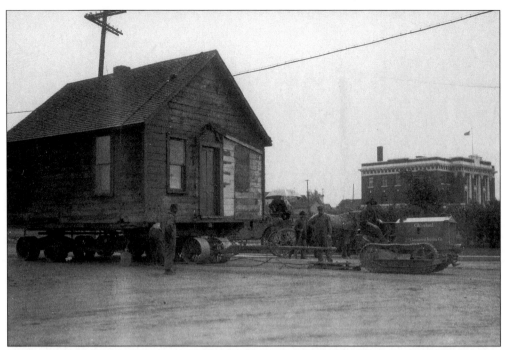

Buildings of all shapes and sizes were moved. We can see from this photo that this house's front porch has been removed. That was done in many but not all cases. The little Cleveland tractor was more than ample to pull these very small buildings.

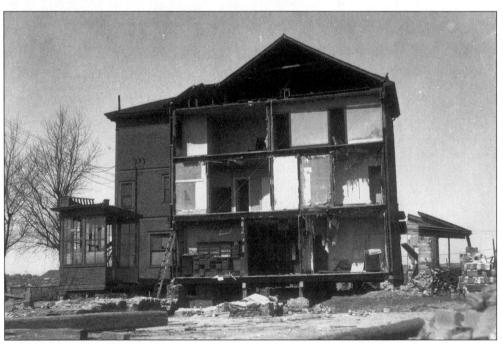

The very large buildings were the ones that needed the most preparation when it came to moving. This is the old Rood Hospital on April 22, 1922. The building is not being torn down. It has simply been taken apart to ease the transport and will be put back together at its new location.

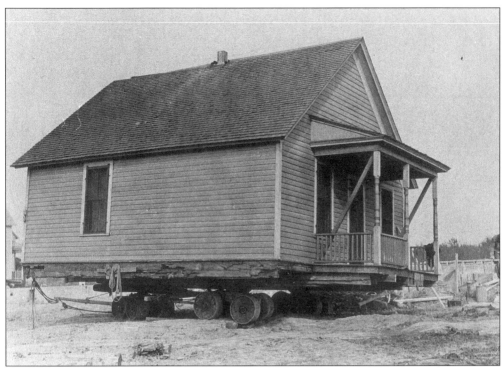

This house has reached its destination and is being pulled backward over the poured cement basement. Inside the basement is the same sort of cribbing that was used to lift the house in the first place. The steel wheels were removed and a timber roller was used to roll the house over the cribbing. When it was all done, the timbers were removed through the basement windows.

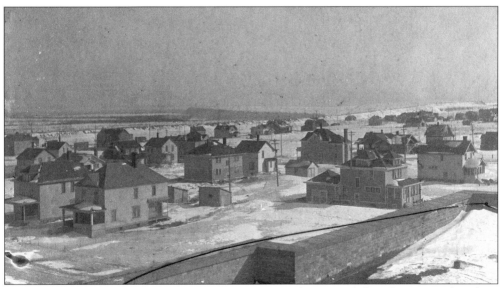

On March 8, 1920, the new hospital was nearing completion, and this photo was taken from the building's roof, looking southeast. Unlike people from other towns in the country, residents from Hibbing would have a difficult time time identifying this picture without knowing what it was. Everything looks so randomly placed and spread out.

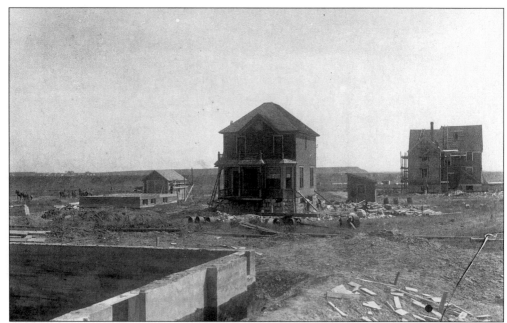

This picture, taken in 1919, looks east from Third Avenue near Cody Street. Cody Street later became Twenty-Second Street. On the left is the home of John B. Sundquist at 2122 Third Avenue East, and on the right, the home of John Chisholm at 2125 Fourth Avenue East. These two homes have rock basements, which were very popular at the time, but you can see that the newer basements in the picture are of the more modern poured cement variety.

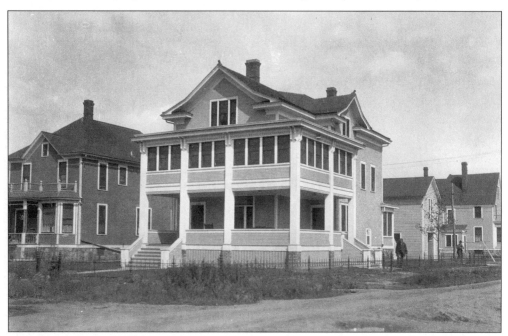

This picture shows the Dear residence safe and sound at its new home on the corner of Third Avenue and Cody Street (Twenty-Second Street) on September 2, 1920. The house still stands on this corner today, although it has been remodeled for apartments.

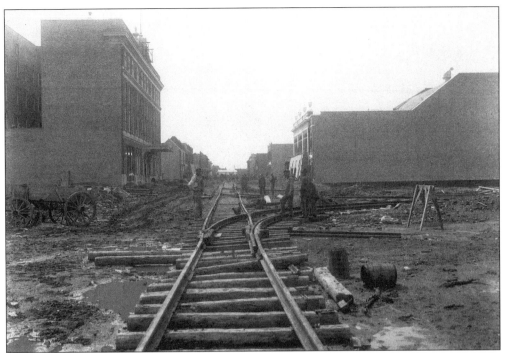

The new town needed a main street with cable car tracks. It was decided that Howard Street would be that main street. This photo of men laying the tracks was taken in late May or early June of 1921. The view is looking west on Howard Street from Sixth Avenue East. On the left is the Androy Hotel.

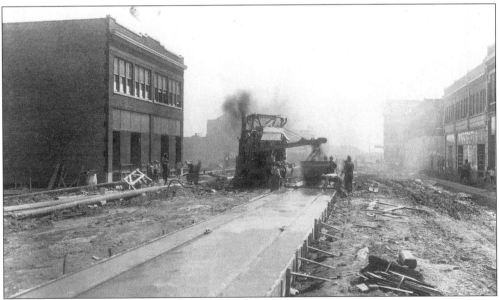

No wooden block paving for this new version of Hibbing, no sir. Taken on June 12, 1921, this photo shows workers pouring cement over the cable car tracks. The view is of Howard Street, looking east from Third Avenue East. For reference, the Androy can be seen at the back of the photo, on the right side.

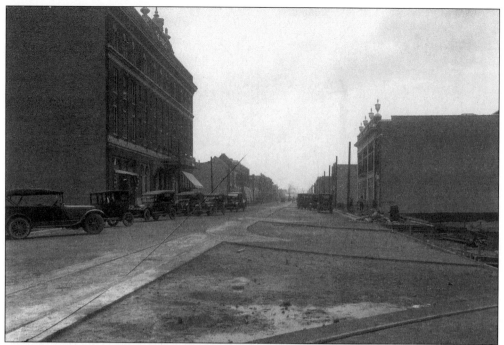

This is another view of Howard Street looking west from Sixth Avenue East, this time on June 29, 1921. The tracks are done, but the rest of the street needs to be paved. The Androy Hotel can be seen on the left.

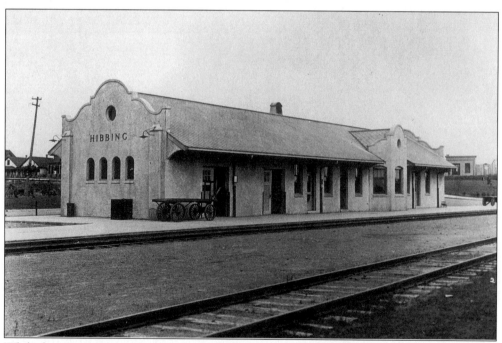

While the new townsite was going up, the old one was coming down. This was one of the buildings that would not make the move. This is a Duluth, Missabe & Northern Railway Company passenger depot in North Hibbing in 1910. Hibbing's first depot was a D.M.&N. boxcar.

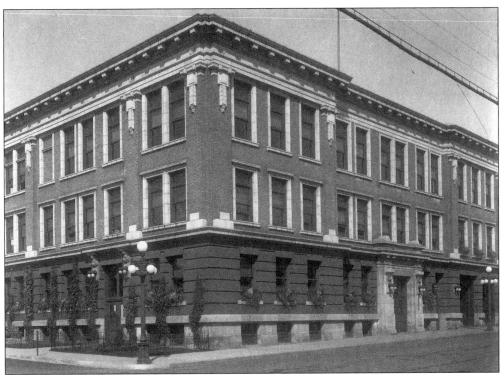

Another building that wouldn't make the trip was the Village Hall, seen here in 1914. Constructed in 1909, on the corner of Second Avenue and Center Street, it was built to take the place of the original Village Hall on Pine Street. This imposing structure housed all of the municipal departments, including fire, police, water, and light.

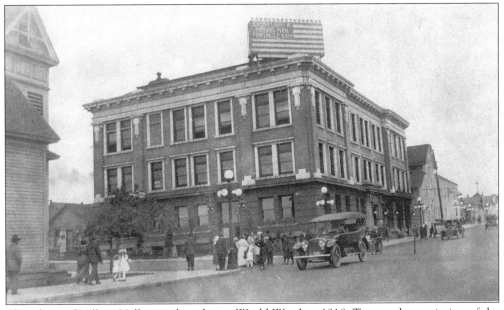

This photo of Village Hall was taken during World War I, c. 1918. True to the patriotism of the people, the flag above the building lights up and reads, "Every light a Hibbing man for Uncle Sam."

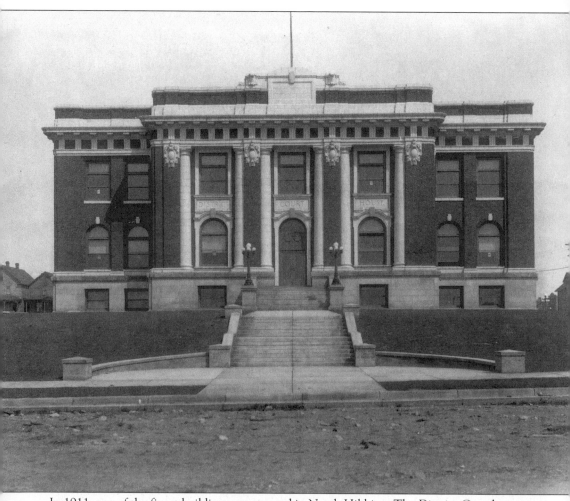

In 1911, one of the finest buildings was erected in North Hibbing. The District Courthouse was thought to have been built far enough south that its lifetime would be long. It was one of the very last buildings to go. This picture of the courthouse was taken in 1919.

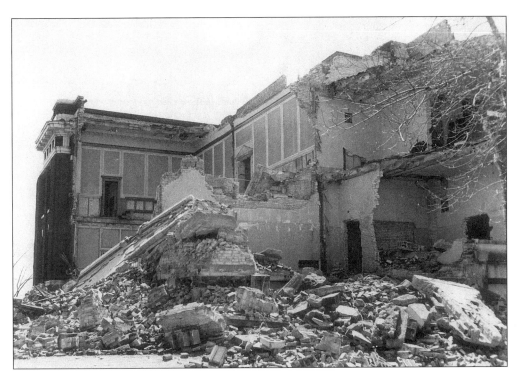

The courthouse had served for 46 years by the time it was destroyed in the summer of 1957. It had been built far enough to the south to stay out of the mine, but not far enough to serve the community efficiently. The men in the bottom picture are picking out the salvageable brick. A new courthouse in South Hibbing was completed in 1956, and an addition was completed in October of 1998.

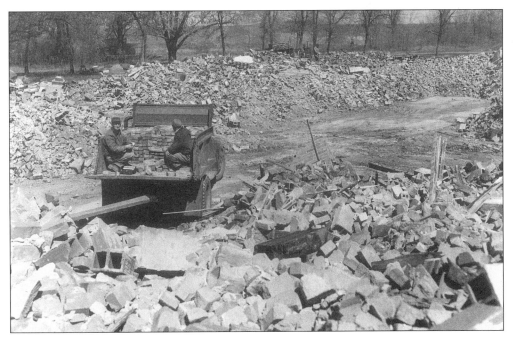

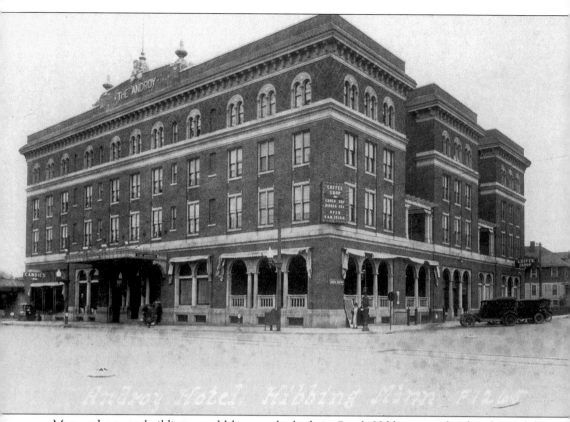

Many other new buildings would have to be built in South Hibbing to take the place of the ones lost and to keep up with the times. References have been made earlier to the Androy Hotel. The hotel had 162 rooms and, then unheard of, 100 baths with hot and cold running water. This historic building was saved from demolition and serves very well today as an apartment house featuring a beautiful ballroom.

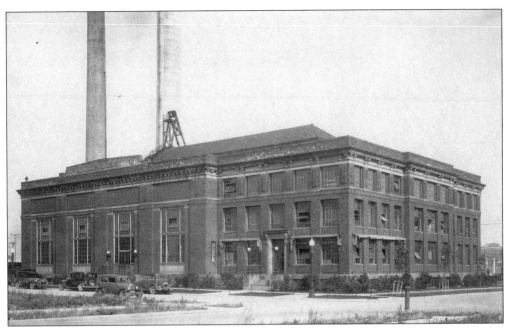

A new public utilities building was needed, not just because the town was moving, but also because the old plant was inadequate. In September of 1920, the Municipal Power Plant was completed and the building is still functioning today.

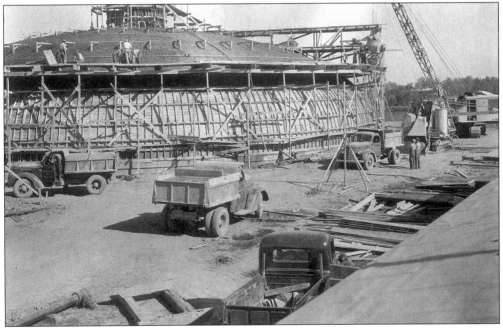

Water and lights are not the only important concerns of a city, as anyone who has had a sewer back up in their basement knows. In 1939, construction was started on a state-of-the-art sewage treatment plant. This photo from August 15th of that year shows the construction well underway. This then state-of-the-art treatment plant, along with many, many buildings in town, is on the National Register of Historic Places.

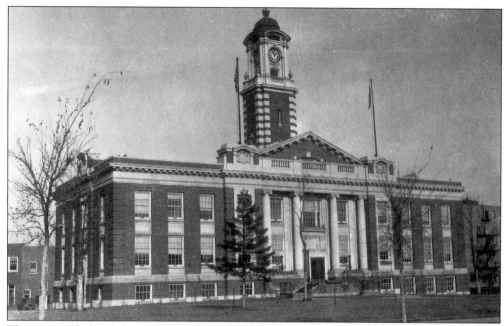

The new city hall, while not quite as large as the old one, is even more impressive. This building was patterned after the *Cradle of Liberty* historic Faneuil Hall in Boston. A Statue of Liberty, erected by the Boy Scouts and the Knights of Columbus, and a water fountain grace the spacious lawn.

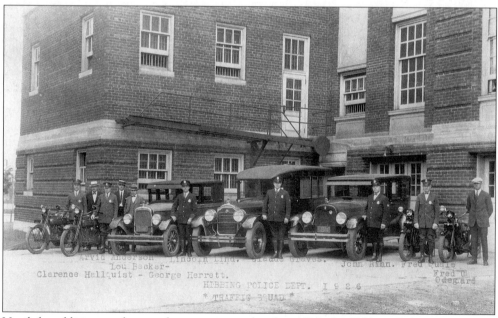

Until the addition on the courthouse was completed in 1998, the Hibbing Police Department was housed in the east end of City Hall. This photo of the 1926 Traffic Squad was taken at the back or jail entrance. The officers, from left to right, are: Clarence Hallquist, unidentified, Arvid Anderson, Lou Becker, George Herrett, Lincoln Lind, Claude Graves, John Rian, Fred Quayle, and Fred Odegard.

Construction of the new Rood Hospital had reached completion by the time this photograph was taken in August of 1920, and accommodated 35 beds. Later, it would be expanded to hold 132 beds and become Hibbing General Hospital. Two additions were built in 1953, and with 190 beds, functioned until 1978. Some attempts to utilize the building for other purposes failed and the hospital was demolished in 1999.

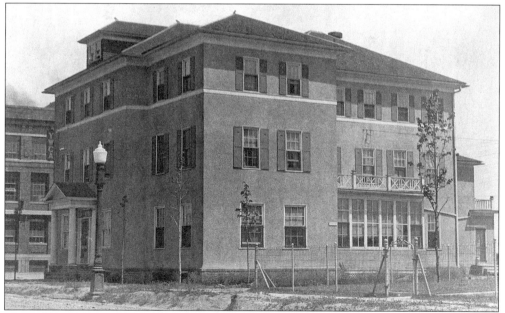

The old Rood hospital, which was moved in 1922, had been donated to the YWCA. The "Y" had first been housed in a parsonage and then in the old Wolfan building in North Hibbing. The YWCA happily called this building home until 1978. This photo was taken in 1924, shortly after being remodeled. The new offices for the Public Utilities Commission stand on the lot today.

The Oliver Club was built by the Oliver Mining Company to serve as a clubhouse for its employees. This photograph, taken on July 8, 1921, shows the club settled in after its move to South Hibbing. Two club members are enjoying the day on the porch. This building was later torn down to make way for the new library, which now occupies the space.

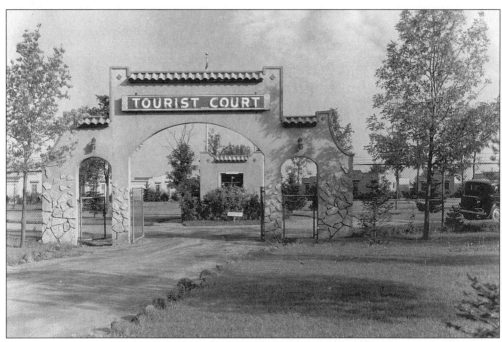

An attractive new addition to the younger version of the town was the tourist court. Built in a southwestern style, it was said to be one of the most beautiful in the country. The cabins here were used as housing for G.I.s returning from WWII. The Tourist Center Senior Citizen's building and Washington Elementary School stand on the grounds today.

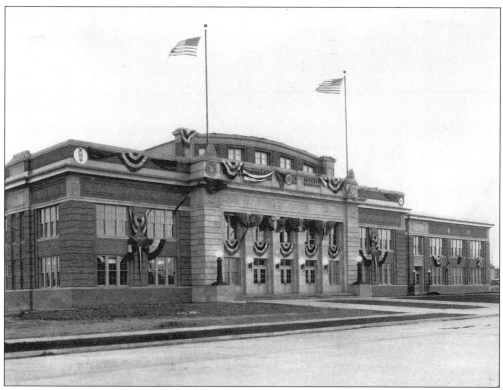

Constructed in 1924, this magnificent recreational building provided a space for many activities including a bowling alley, curling rink, and a full size skating rink. The stone lettering above the front doors reads, "Let us keep alive the spirit of America as exemplified in the lives of those whose service we honor."

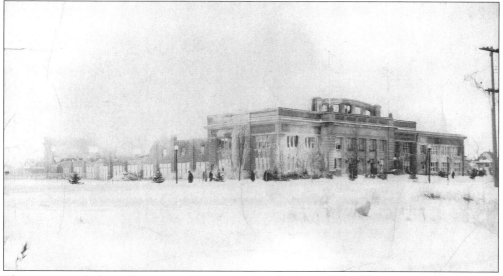

The town was shaken when, one cold winter's day, the beautiful building was totally destroyed by fire. This photo from December 28, 1933, shows a building that has become barely a shell. It had burned nearly all the way to the ground.

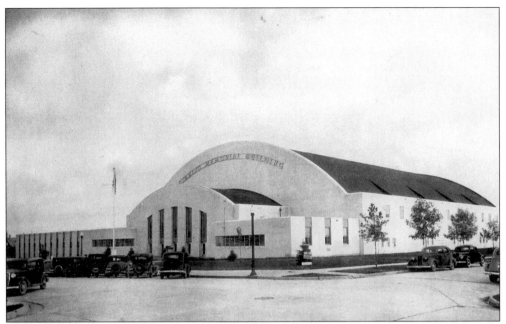

That was not the end of the story for the beloved building. It was rebuilt in 1934 as the Memorial Building, with a fresh style and was even bigger and better. The building looks much the same today as it did in 1934, and houses curling rinks, a full size arena for hockey, skating, basketball, rodeo, circuses, shows, or large banquets. It also contains a little theater, a dining room with a commercial kitchen, meeting rooms, and the Hibbing Historical Museum.

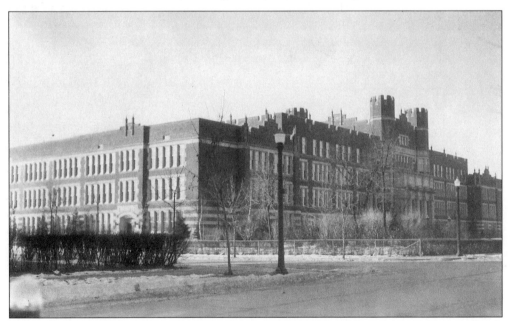

When the Oliver Mining Company was trying to convince residents to move down to South Hibbing, they decided to sweeten the deal by enticing them with some very impressive buildings. Three of those buildings are the Androy Hotel, City Hall, and the famous Hibbing High School. Building the school had cost almost $4 million by the time it was finished in 1923.

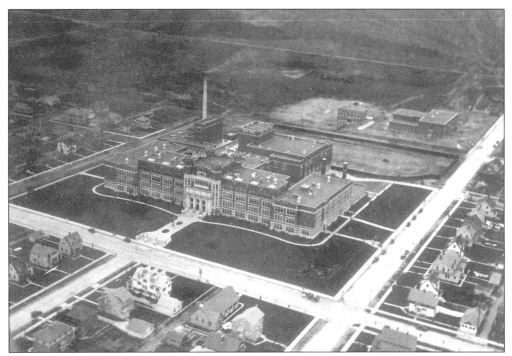

At the time of its construction, the school was still at the edge of town, and railroad tracks were laid to bring out supplies and equipment. It was meant to look like a castle in the woods, and from the angle of this photo, one can see the turrets, which helped to achieve that look. Cheever Field is also visible. The stadium had to be removed in order to make room for the new addition that was completed in 1991

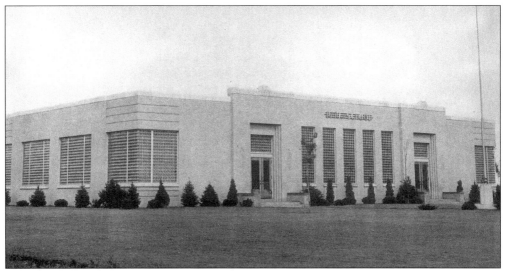

One of the most interesting of the new schools was the Park School, so named because of its proximity to Bennett Park. Built in 1935, this building was about as modernistic as you could get. The air, which is humidified and conditioned, is constantly circulated and the lighting is controlled by photoelectric cells. Because all the windows are made of glass block and none open to the outside, it was also known as the glass school.

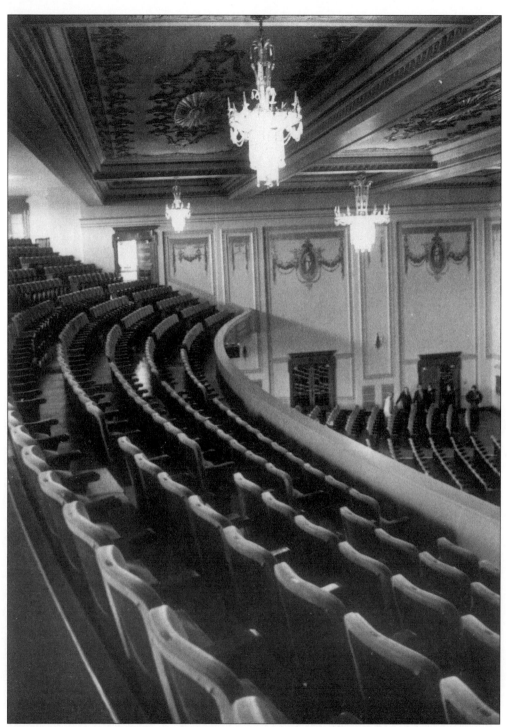

Though the entire building is a work of art, it is probably the auditorium that receives the most fanfare. This beautiful room is modeled after the Capitol Theater of New York City, and has a 40 by 60 foot Broadway-style stage, hand molded plaster ceilings, velvet seats, a rare Barton pipe organ, box seats, and last but not least, imported Belgian crystal glass chandeliers.

Seven

PARADES OF PATRIOTISM, CELEBRATIONS, AND THE ST. LOUIS COUNTY FAIR

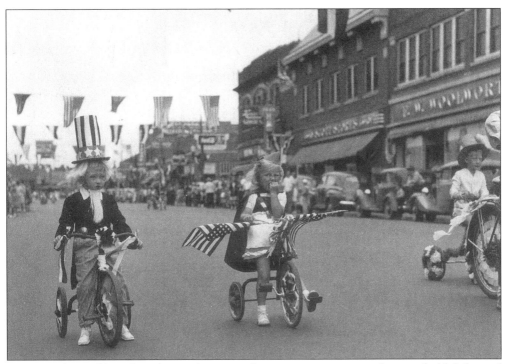

One way that Hibbing has always chosen to show its patriotism is with a good old-fashioned parade. This great shot was taken on Howard Street during World War II in the mid 1940s. In World War II, Hibbing produced more commissioned and non-commissioned officers, percentage wise, than any other U.S. city.

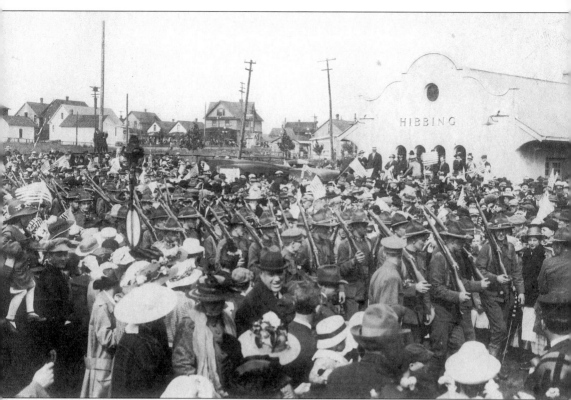

An incredible 10 percent of Hibbing's population served in World War I and surely, neither world war could have been won if not for all of the iron ore pouring out of her mines. Fourteen million tons of ore came out of the Hull-Rust-Mahoning alone in 1917. The same year, this photo was taken showing the send off for the men of Company M.

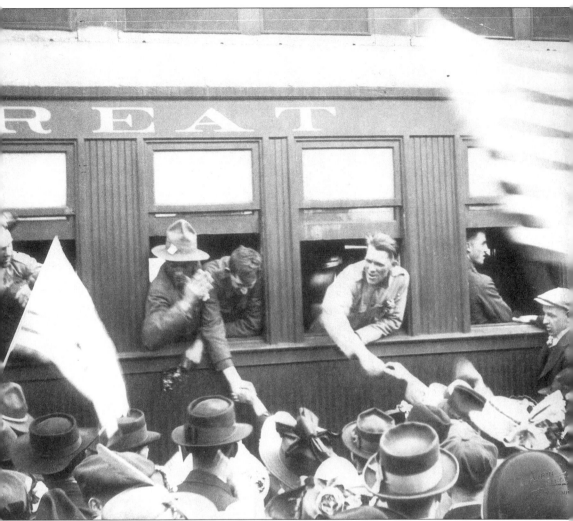

Just one year earlier in 1916, Company M had received another send off. Here they are saying goodbye to friends and family as they start on their way to the Mexican border. They will only return home for a couple of months before they will have to leave to fight for their country in another war.

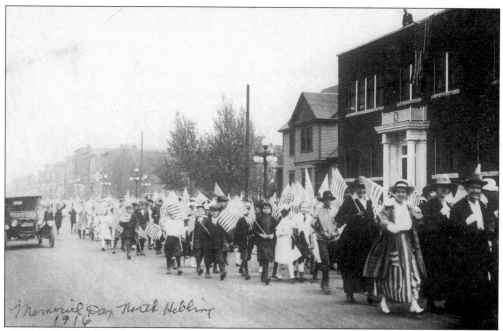

This picture of a North Hibbing parade was taken on Memorial Day in 1916. The first woman on the right is identified as Mona Pereforead. Notice the "Stars and Stripes" costume of the woman just behind her.

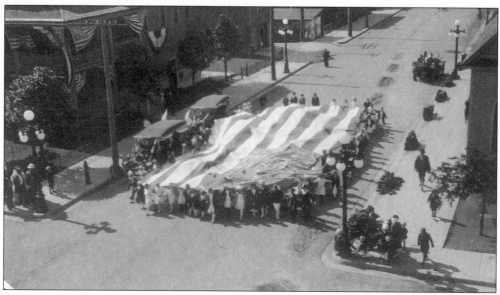

This photo may have been taken the same day as the above picture. In any case, it looks like the whole town turned out to help with this unique float.

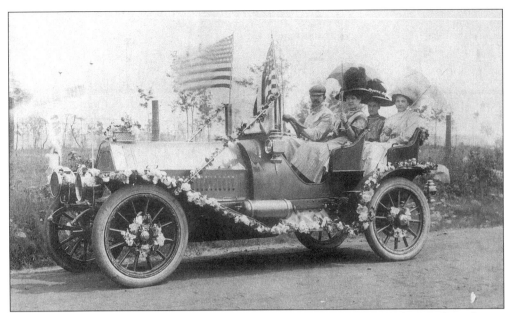

The car in this picture is dressed up for the Fourth of July parade in 1910. The people in the car are, from left to right: Mr. Krost, Alma Isaacson, Pauline Van Gaut, and Ruth Erviatuiger. The car was owned by Mrs. Dottie M. Power, who became sole owner of the Itasca Bazaar Company in 1913. Mrs. Power was married to Walter J. Power, former village president and brother of Victor Power.

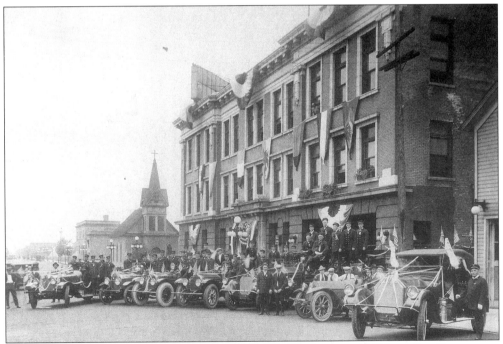

Civil departments also know how to have a good time. The entire Hibbing Fire Department turned out to pose for this Fourth of July photograph in front of the City Hall building in North Hibbing. It was probably taken about 1918 since the lighted flag is seen on the roof.

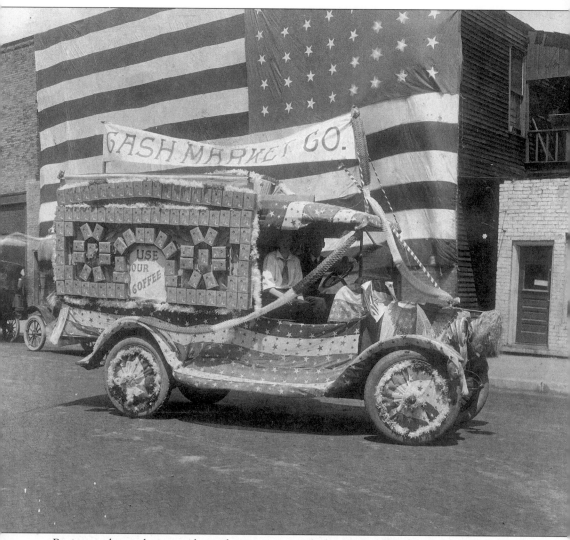

Businesses have always used parades as a means of advertising, and the Cash Market Company of 709-711 Third Avenue sure knew how to advertise their coffee. The picture of this float was taken about 1915 or 1916.

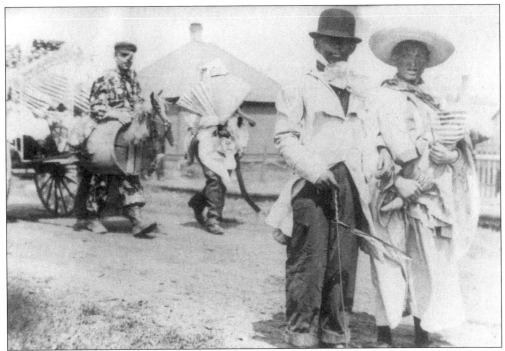

Celebrating holidays and special events was not just reserved for the town folk. Every location had their own ways to celebrate too. These silly characters were captured on film at a Fourth of July parade in Stevenson Location.

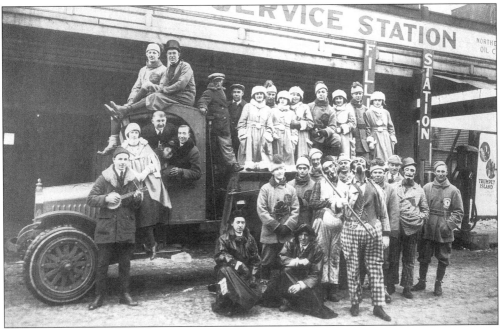

A winter celebration in town that is eagerly awaited every year by students and adults alike is the Hibbing Winter Frolic. These "frolickers" pose in front of William Close's store on Center Street on February 22, 1922.

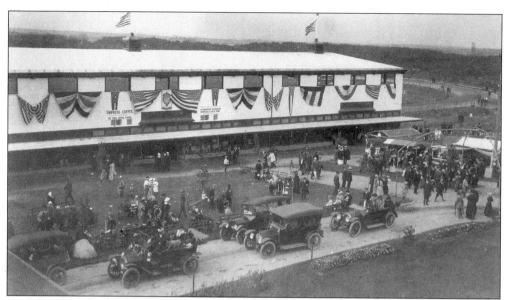

Starting in the late 1800s, yearly agricultural expositions were taking place in Duluth. By the early 1900s, however, with the help of Fred Twitchell, these expositions had moved to Pool Location in Hibbing to become the St. Louis County Fair. This photograph of the early fairgrounds was taken about 1914.

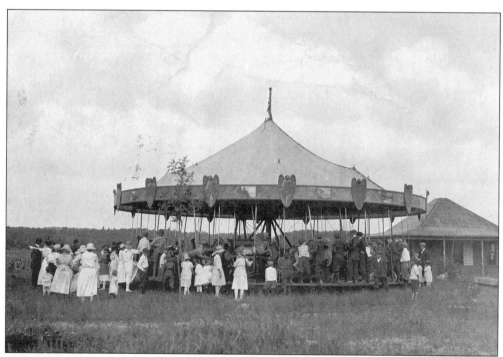

The most popular ride at any carnival has always been the carousel or merry-go-round. It's a ride that anyone, young or old, can enjoy. The setting up of this early model seems to have caught the interest of quite a crowd who eagerly await their turns on the ride.

110

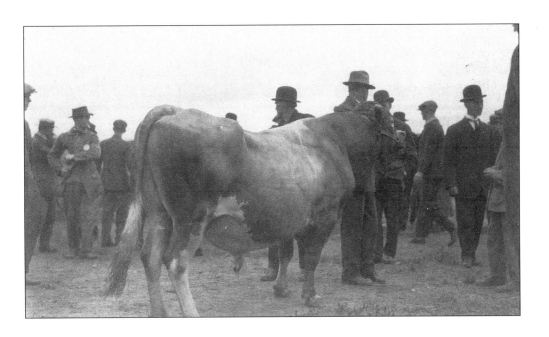

Because farmers came from all over the Range and Duluth to participate in the fair, it was the perfect place to show off impressive produce, new farming implements and practices, and prize-winning animals of all sizes. The ones in these pictures just happen to be of the large variety.

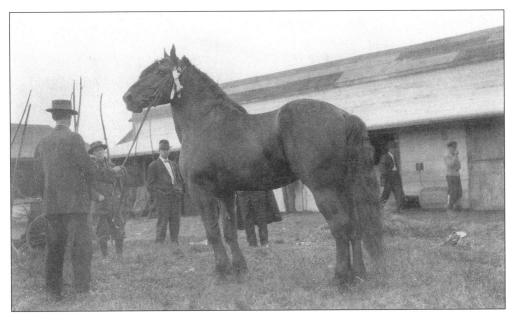

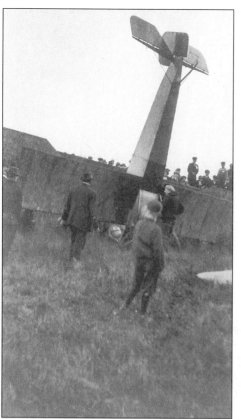

Early on, the need for entertainment to draw people to the fair was recognized. One way that was very popular was airshows. Even though accidents did happen, most shows were quite a success when the weather permitted. The first "flyers" in Hibbing, Frank Banks and Earl Cook, were probably present when these shots were taken.

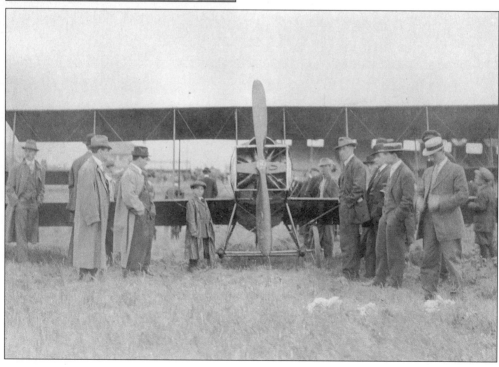

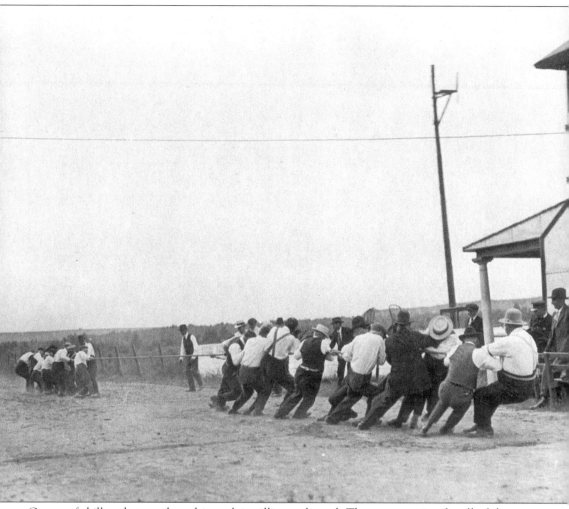

Games of skill and strength and just plain silliness abound. There were prizes for all of them. The winners of the men's tug-o'-war contest enjoyed a box of cigars for their efforts, while the ladies had a similar event and were rewarded with a handsome box of candy.

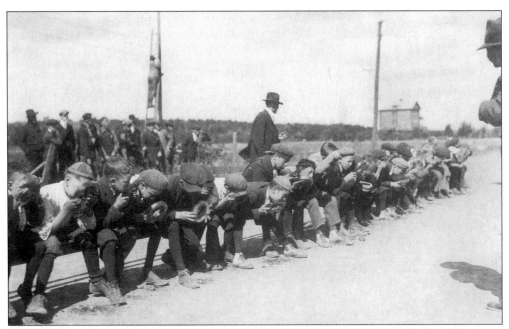

The children had their own events, like eating contests. This is a photo of the boys' blueberry eating contest. You can tell by the looks on their faces that they mean business. Though slightly fuzzy, the Pool Location School can be seen in the background.

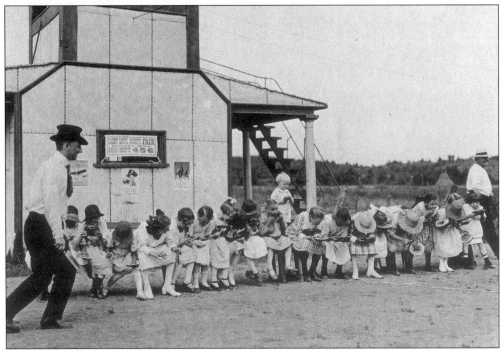

The girls did not have to eat anything so messy and unladylike as blueberries. They got watermelon! One little fellow just could not resist and had to have some watermelon too. The first prize in the girls' contest was a silk hair ribbon, and the second prize was a box of candy.

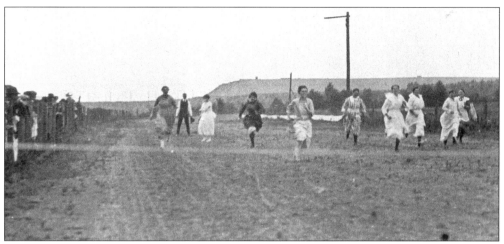

There were, of course, foot races for everyone. The race shown in this picture was for married ladies only. They are rushing to be the first one through the finish line to win the first prize: a pair of silk hose.

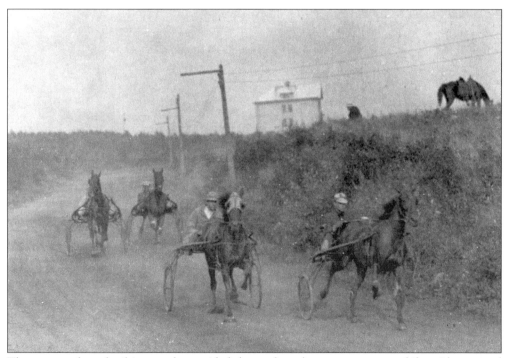

The race track at the fairgrounds provided the perfect place to race automobiles, sidecars, and horses. In fact, the Hibbing Speedway Association was organized in 1900, with Fred Twitchell as president. "The sport of kings" really took off the next year when the Hibbing Park and Speedway opened.

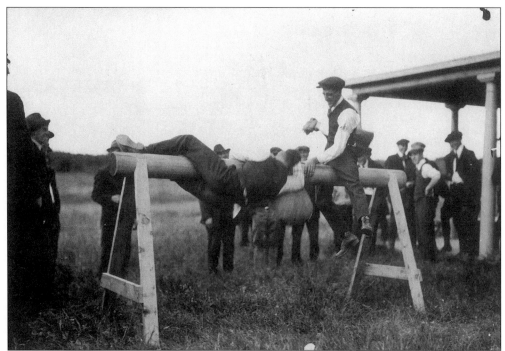

The fairgrounds were also used for other community gatherings like the yearly Oliver Club Picnic. There were games a plenty at the picnic, too. These men are trying to knock each other off of this log with weighted gunnysacks. It does not look very dignified, but it does look like fun.

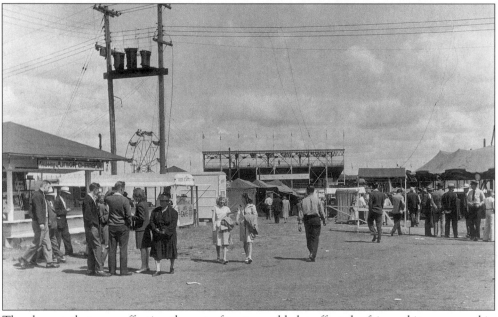

The changes that were affecting the rest of town would also affect the fair, and it was moved in 1924 to this spot in South Hibbing. The fair would stay here and look much the same for the next 75 years, until it was moved to Chisholm in 1999. In the middle of this photo, you can see the back of the grandstands of the Hibbing Raceway that is still very much in use today.

Eight

PARKS, PITS, AND FRANK

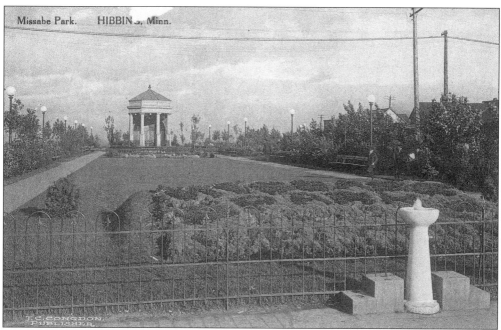
Missabe Park. HIBBING, Minn.

One thing that was prevalent from the start of the town and continues today is the importance of a good park system. As one of the earliest of these spaces, one would find Missabe Park a serene place to sit and relax or visit with friends. It had a fountain and a gazebo for the band. It also had beautiful gardens. As you can see from this photo, the words "Missabe Park" are spelled out in flowers.

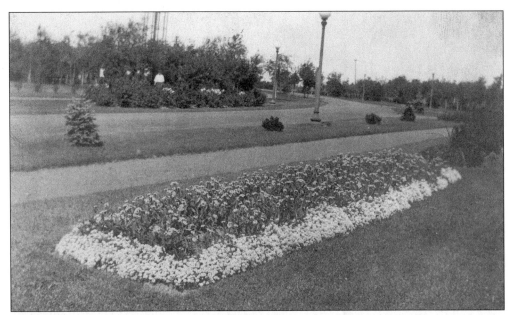

The biggest and best park came about right in between the north and south parts of town. Bennett Park, named after Russell Bennett, opened in 1914 on a 46-acre tract of land. It took almost two years to landscape the leased property in order to open.

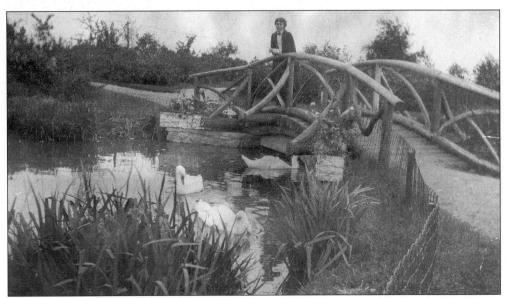

When the Morrell and Nichols landscaping firm were done with Bennett Park, they had created a work of art. Cobblestone-lined walking paths wove through lush lawns and around gardens, streams, and a pond. The pond, with its quaint little handcrafted bridge and elegant swans, was a very popular spot to pose for a photograph.

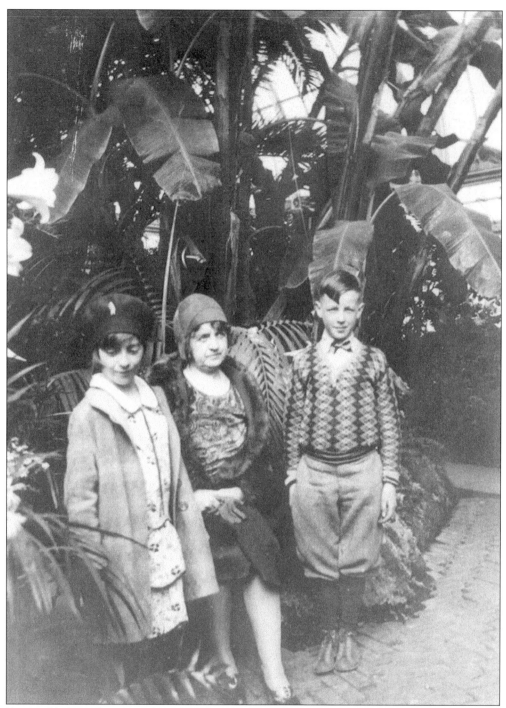

You could always lose yourself in the foliage of one of the parks five greenhouses for an afternoon if you chose. The largest of these was the conservatory that housed many tropical plants of all shapes and sizes. This photo was taken by Robert Ray Kreis of his family in April of 1929. They are, from left to right: Cora Patricia Kreis, May (Fuller) Kreis, and Bertram Ray Kreis.

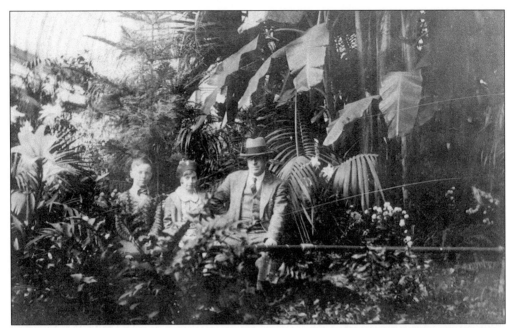

This picture was taken on the same day by May Kreis. This time posing for the camera, from left to right, are Bertram, Cora, and Robert Ray Kreis. Robert "Ray" was the manager of the football team that played at Green Bay in 1923, as well as a pharmacist, long time school board member, and member of the village council.

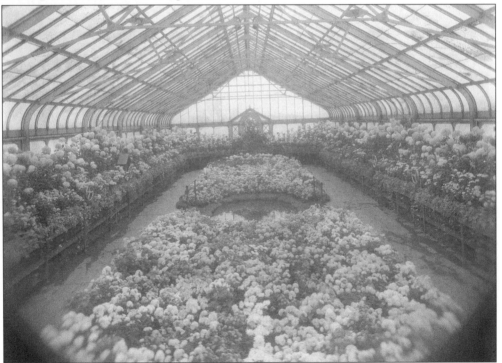

This photograph of thousands of chrysanthemums was taken in a park greenhouse during the 1929 Mum Show. The chrysanthemums were sold by the Red Cross.

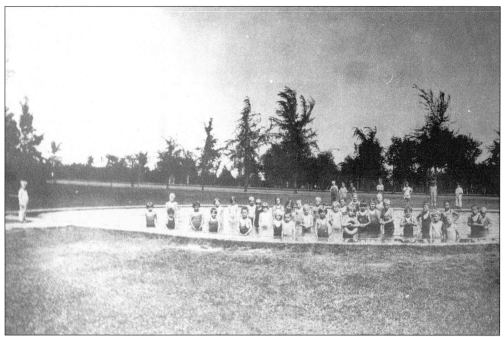

Another one of the favorite places to hang out was one of the two pools in the park. As seen in this photo from 1921, the pool was not very deep, but it was brimming with children. These pools were located across Third Avenue, where the southwest corner of the park is today.

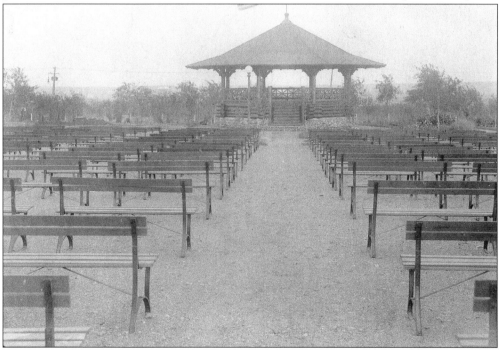

The park's bandstand has always been a very good place to catch a show or performance by the Hibbing Band. These benches would fill right up many times a year with people hungry for good music and family entertainment.

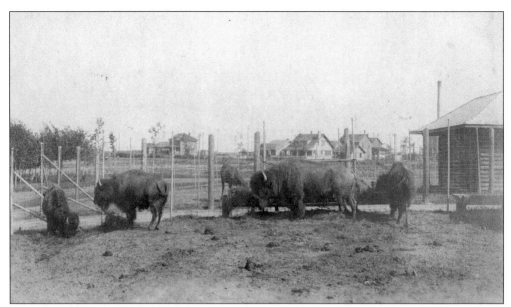

Even though the pools and the greenhouses were spectacular, nothing can really hold a candle to live, wild animals, and Bennett Park had those too! This picture, taken about 1921 or 1922, shows a few of the buffalo, including a little calf seen on the left.

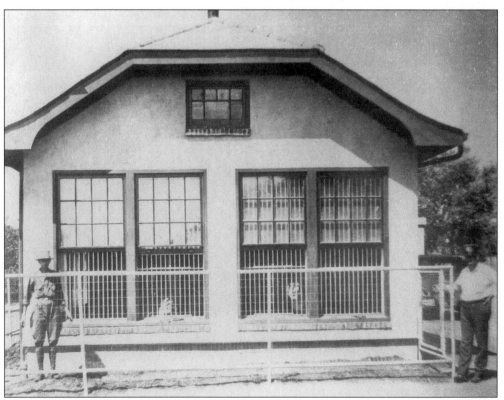

At the back of the Animal House, one could come face to face with the two male lions seen here with their caretaker, Mr. Hanson, in 1922. The other man in the photograph is unidentified.

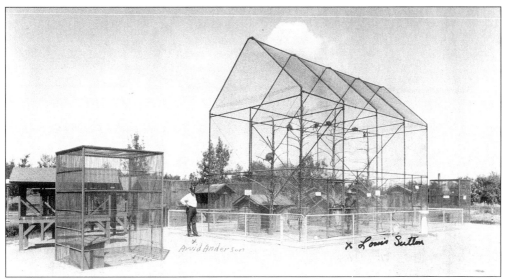

This photo, taken in 1921, shows the temporary monkey house. Obviously, these monkeys could not spend a winter in this cage, so more permanent quarters had to be built. Also in the photo, from left to right, are Arvid Anderson and Louis Sutton. Other animals included in the zoo were seals, wolves, elk, antelope, and deer. Just like everything else in the town, the park has changed and no longer includes this zoo.

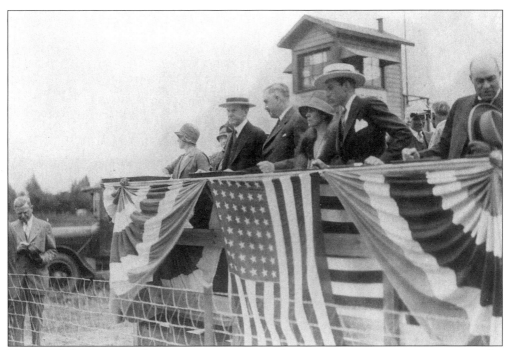

Not a park but a tremendous tourist attraction, is the greatest open pit iron ore mine in the world, the Hull-Rust-Mahoning. President Calvin Coolidge, on his visit on August 2, 1928, put it most eloquently when he said, "That's a pretty big hole!" Viewing the pit from the observation tower area, from left to right: unidentified, Dr. Blacklock, unidentified, unidentified, President Coolidge, (?) Melskill, Mrs. C., John C., unidentified, unidentified, and William Tappan.

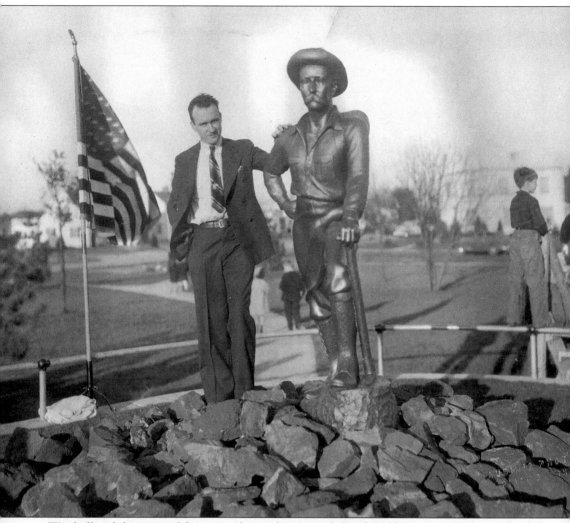

We shall end this story of the town where it began, with Frank Hibbing. In 1937, it was decided that Hibbing should have a monument to the man who started it all and a committee was formed, headed by J.F. Twitchell. A local Hibbing man, who had recently graduated from the Minneapolis School of Art, was contracted to sculpt the statue. The sculptor, Robert C. Mitchell, is shown here with his finished product at the 1941 dedication of the Frank Hibbing Memorial Park.

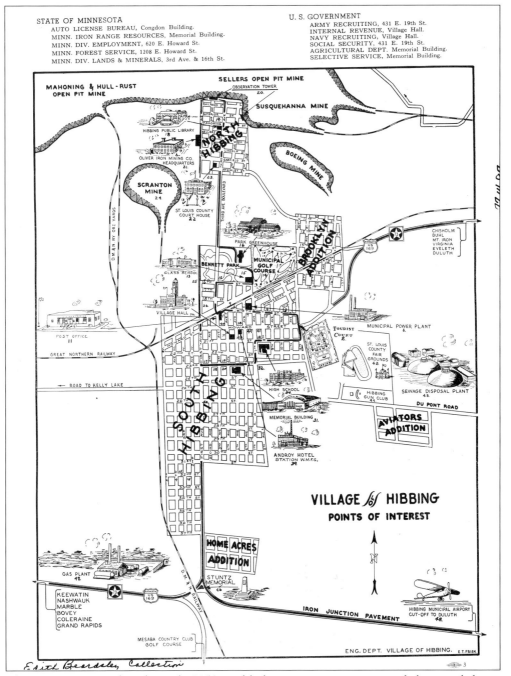

This map was created in the early 1950s and helps to give a perspective of places and things that no longer exist, like the park greenhouse, and some that do, like the Androy Hotel.

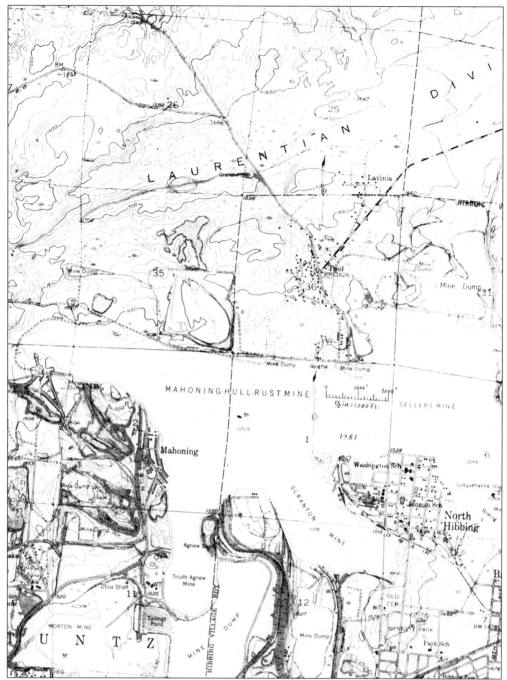

This is a map of the Hull-Rust-Mahoning mine pit and the surrounding area in 1951. This map shows Lavinia, Pool, and Mahoning Locations, as well as Bennett Park and what was left of North Hibbing.

126

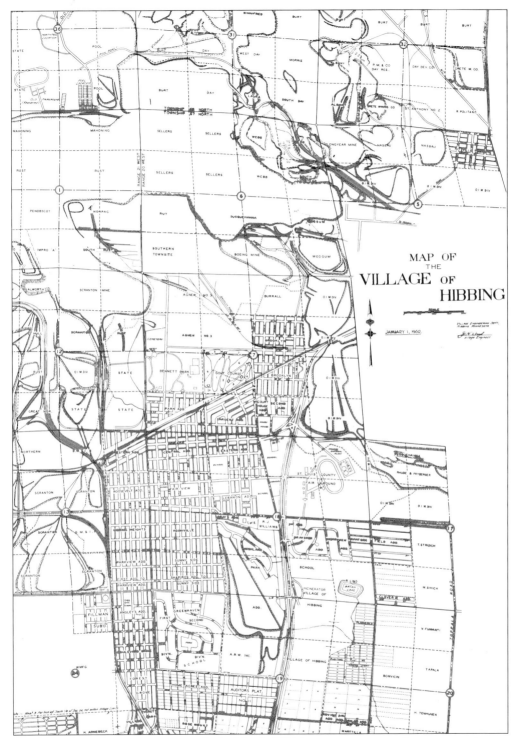

By 1960, when this map was created, the North Hibbing streets were no longer appearing on the maps as there was nothing much of them left. This map does, however, show Pool Location which was on its very last legs as a viable community.

127

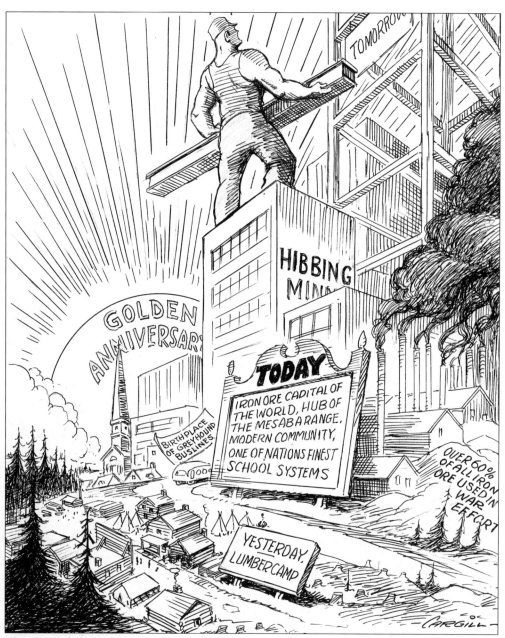

This illustration was drawn for Hibbing's Golden anniversary in 1943. It depicts the growth of the town starting as a lumber camp, then becoming the Ore Capital of the World and growing right into tomorrow with a bright future.